Barbara Hess

D1394384

LUCIO FONTANA

1899–1968

"A New Fact in Sculpture"

TASCHEN

HONG KONG KÖLN LONDON LOS ANGELES MADRID PARIS TOKYO

COVER:
Concetto spaziale, Attese
(Spatial Concept, Expectations), 1959
Watercolor on canvas, 91 x 91 cm
Japan, location unknown

BACK COVER:
Lucio Fontana working on models for
the fifth door of Milan Cathedral, 1951

ILLUSTRATION PAGE 1:
Seated Nude, 1964–1965
Black and yellow ink on paper, 100 x 70 cm
Milan, Fondazione Lucio Fontana

ILLUSTRATION PAGE 2:
Lucio Fontana amongst his
Nature terracotta sculptures, 1964

To stay informed about upcoming TASCHEN titles,
please request our magazine at www.taschen.com/magazine or write to
TASCHEN America, 6671 Sunset Boulevard, Suite 1508, USA-Los Angeles,
CA 90028, contact-us@taschen.com, Fax: +1-323-463.4442.
We will be happy to send you a free copy of our magazine
which is filled with information about all of our books.

© 2006 TASCHEN GmbH
Hohenzollernring 53, D–50672 Köln
www.taschen.com

© Fondazione Lucio Fontana, Milan
Project management: Petra Lamers-Schütze, Cologne
Coordination: Christine Fellhauer, Cologne
Translation from German: John W. Gabriel, Worpswede
Production: Thomas Grell, Cologne
Layout: Claudia Frey, Cologne
Cover design: Claudia Frey, Cologne

Printed in Germany
ISBN-13: 978-3-8228-4918-7
ISBN-10: 3-8228-4918-9

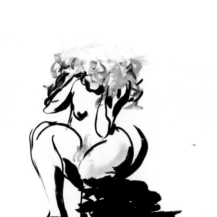

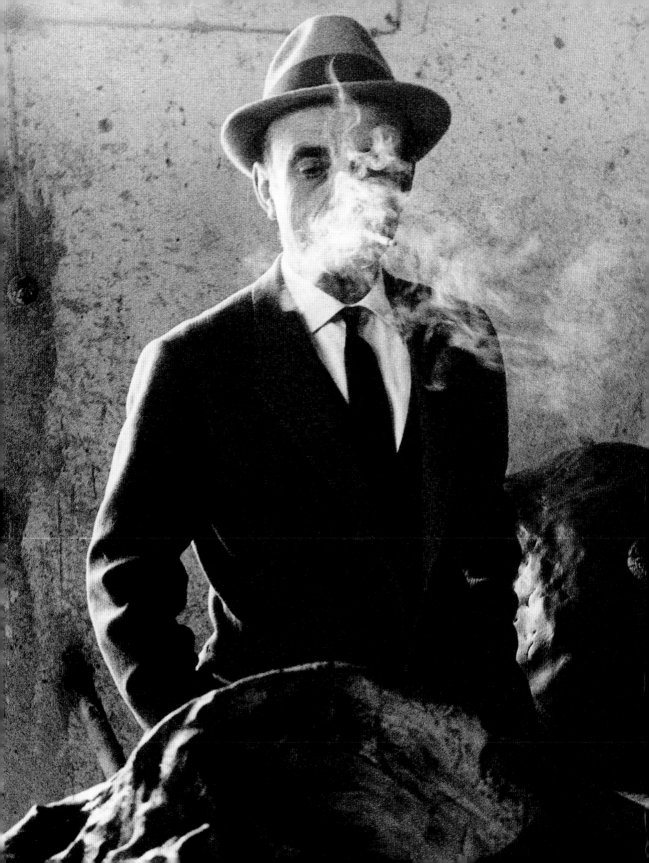

Contents

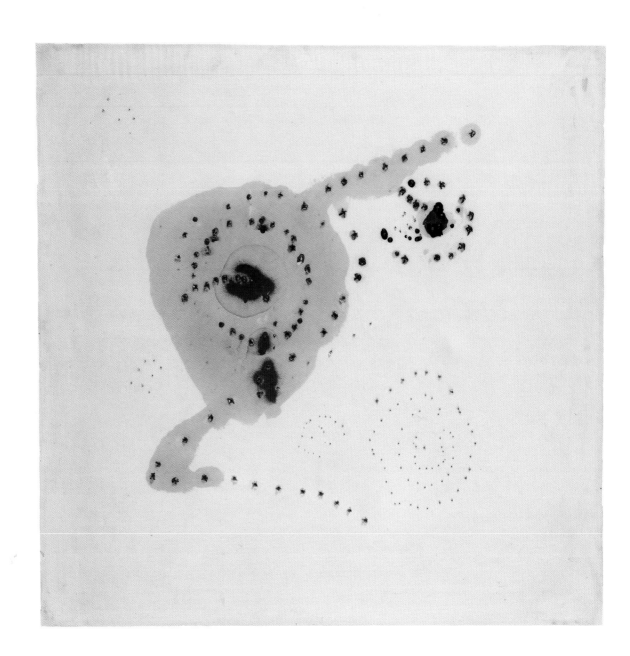

"My discovery was the hole, period."

Seldom has an artist's name been so closely linked with a singular achievement as in the case of Lucio Fontana. In 1949 he mounted a square, one meter by one meter sheet of white paper on a canvas (p. 8). Instead of drawing or painting on it, Fontana perforated the sheet from the back with a number of holes, concentrated at the center and extending across the sheet in irregular circular and spiral patterns. Around the edges of the holes, the material protruded above the picture surface and, in oblique light, cast shadows on it. Rather than treating the paper as a two-dimensional plane, Fontana evidently viewed it as a plastic material whose potentials for creating a sense of depth were worth exploring. In retrospect, he would describe this moment as the crucial turning point in his career. In an interview with Carla Lonzi in the 1960s, he declared, not without a certain pathos, "My discovery was the hole, period. And it wouldn't matter if I had died after this discovery …"

From the emergence of the first *Buchi*, holes or perforations, a term based on Fontana's personal usage, he gave all of his works the collective title *Concetto spaziale*, or Spatial Concept. By making an apparently simple gesture—which would be reinterpreted again and again over the years—he managed to overcome the illusionistic nature of painting and integrate real space, and real voids, into the two-dimensional work of art. This fulfilled an expectation with regard to the development of modern art which he and his students had advanced in 1946, in the *Manifiesto Blanco*, or *White Manifesto*: the capacity of art to "liberate itself from the Renaissance heritage." Part of the "Renaissance heritage" was the creation of an illusion of depth by means of perspective; the physical opening of the picture surface implied creating a continuum between the space occupied by the viewer and the pictorial space.

In the wake of his 1949 discovery, Fontana developed the idea of the perforated painting surface in hundreds of variants. The apertures varied in size, were ornamentally or regularly arranged, and made either from the front or the back of the surface. Their spatial effect was occasionally heightened by the addition of sequins or shards of colored glass, and instead of paper, canvas was sometimes employed, either raw or painted in oils. Despite his obsessive concern with the gesture of perforation, Fontana emphasized the importance of conception over that of execution, stating that a single act of perforation or incision "… would have sufficed. Everything else, the different

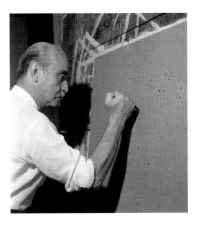

Lucio Fontana working on his *Buchi*, 1960

ILLUSTRATION PAGE 6:
Concetto spaziale (Spatial Concept), 1952
Oil on paper, mounted on canvas, 79 x 79 cm
Paris, Centre Georges Pompidou,
Musée National d'Art Moderne

Concetto spaziale, 1949
White paper, mounted on canvas, 100 x 100 cm
Rome, Galleria Nazionale d'Arte Moderna

colors, the different arrangement of the cuts or holes, are variations for the public."

A wider public saw the *Buchi* for the first time in 1952, at a Fontana show at the Galleria del Naviglio in Milan, and in a television program broadcast by the Italian national network, RAI. The program was devoted to an official announcement of the *Manifesto del Movimento Spaziale per la Televisione* (Manifesto of the Spatialist Movement for Television), authored by Fontana in collaboration with several other artists. The manifesto's language was shot through with the same euphoric faith in technological progress found in the prewar Futurist manifestoes. The authors advocated a space-related art that, with the aid of modern technology, would be liberated from its material fetters and "even in a single minute of broadcasting time—would last 1000 years in outer space." On the television program, Fontana's first perforated work was shown illuminated from behind to evoke a sense of cosmic space. As late as the 1960s, Fontana still continued to emphasize: "As a painter, while working on one of my perforated canvases, I do not want to make a painting: I want to open up space, create a new dimension for art, tie in with the cosmos as it endlessly expands beyond the confining plane of the picture."

In the context of Fontana's career, the *Buchi* were a belated discovery. At the time of their emergence he was already 50 years old and could look back on over 25 years of productive and diverse work, especially in sculpture. Before he made that other pioneering gesture with which his name is now associated—incisions in the canvas known as *Tagli*—another, almost ten-year-period was to pass. Fontana's contemporaries seem to have reacted with twofold amazement to his 1949 "discovery." Not only because cutting or punching holes in the canvas—and especially Fontana's sole focus on this device—represented a radical gesture, but also because many perceived it as a shift to another medium and a break with the artist's previous practice as a sculptor. "Laughter that went on for years!" Fontana recalled the reaction. "People asked me, 'What are you doing, anyway? You of all people, Lucio, an excellent sculptor …' For them, I was good before and an ass afterwards. And I managed to participate in the [1950 Venice] Biennale and pull the wool over the commission's eyes, because actually I had been invited with sculptures! But I didn't breathe a word, and went to the Biennale with 20 perforated canvases. You can imagine the reaction: 'These are not sculptures at all, they're paintings!' … For me, they are perforated canvases that represent sculpture, a new fact in sculpture."

"You can say whatever you like about the holes. But a new direction in art is going to emerge purified from them (Giotto told me this in Padua, and Donatello confirmed it)."
LUCIO FONTANA, 1953

"My discovery was the hole, period."

Seldom has an artist's name been so closely linked with a singular achievement as in the case of Lucio Fontana. In 1949 he mounted a square, one meter by one meter sheet of white paper on a canvas (p. 8). Instead of drawing or painting on it, Fontana perforated the sheet from the back with a number of holes, concentrated at the center and extending across the sheet in irregular circular and spiral patterns. Around the edges of the holes, the material protruded above the picture surface and, in oblique light, cast shadows on it. Rather than treating the paper as a two-dimensional plane, Fontana evidently viewed it as a plastic material whose potentials for creating a sense of depth were worth exploring. In retrospect, he would describe this moment as the crucial turning point in his career. In an interview with Carla Lonzi in the 1960s, he declared, not without a certain pathos, "My discovery was the hole, period. And it wouldn't matter if I had died after this discovery …"

From the emergence of the first *Buchi*, holes or perforations, a term based on Fontana's personal usage, he gave all of his works the collective title *Concetto spaziale*, or Spatial Concept. By making an apparently simple gesture—which would be reinterpreted again and again over the years—he managed to overcome the illusionistic nature of painting and integrate real space, and real voids, into the two-dimensional work of art. This fulfilled an expectation with regard to the development of modern art which he and his students had advanced in 1946, in the *Manifiesto Blanco*, or *White Manifesto*: the capacity of art to "liberate itself from the Renaissance heritage." Part of the "Renaissance heritage" was the creation of an illusion of depth by means of perspective; the physical opening of the picture surface implied creating a continuum between the space occupied by the viewer and the pictorial space.

In the wake of his 1949 discovery, Fontana developed the idea of the perforated painting surface in hundreds of variants. The apertures varied in size, were ornamentally or regularly arranged, and made either from the front or the back of the surface. Their spatial effect was occasionally heightened by the addition of sequins or shards of colored glass, and instead of paper, canvas was sometimes employed, either raw or painted in oils. Despite his obsessive concern with the gesture of perforation, Fontana emphasized the importance of conception over that of execution, stating that a single act of perforation or incision "… would have sufficed. Everything else, the different

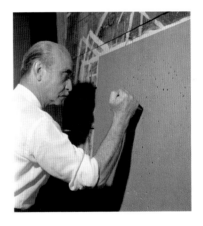

Lucio Fontana working on his *Buchi*, 1960

ILLUSTRATION PAGE 6:
Concetto spaziale (Spatial Concept), 1952
Oil on paper, mounted on canvas, 79 x 79 cm
Paris, Centre Georges Pompidou,
Musée National d'Art Moderne

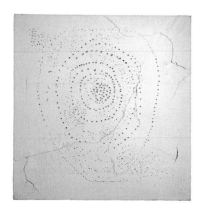

Concetto spaziale, 1949
White paper, mounted on canvas, 100 x 100 cm
Rome, Galleria Nazionale d'Arte Moderna

colors, the different arrangement of the cuts or holes, are variations for the public."

A wider public saw the *Buchi* for the first time in 1952, at a Fontana show at the Galleria del Naviglio in Milan, and in a television program broadcast by the Italian national network, RAI. The program was devoted to an official announcement of the *Manifesto del Movimento Spaziale per la Televisione* (Manifesto of the Spatialist Movement for Television), authored by Fontana in collaboration with several other artists. The manifesto's language was shot through with the same euphoric faith in technological progress found in the prewar Futurist manifestoes. The authors advocated a space-related art that, with the aid of modern technology, would be liberated from its material fetters and "even in a single minute of broadcasting time—would last 1000 years in outer space." On the television program, Fontana's first perforated work was shown illuminated from behind to evoke a sense of cosmic space. As late as the 1960s, Fontana still continued to emphasize: "As a painter, while working on one of my perforated canvases, I do not want to make a painting: I want to open up space, create a new dimension for art, tie in with the cosmos as it endlessly expands beyond the confining plane of the picture."

In the context of Fontana's career, the *Buchi* were a belated discovery. At the time of their emergence he was already 50 years old and could look back on over 25 years of productive and diverse work, especially in sculpture. Before he made that other pioneering gesture with which his name is now associated—incisions in the canvas known as *Tagli*—another, almost ten-year-period was to pass. Fontana's contemporaries seem to have reacted with twofold amazement to his 1949 "discovery." Not only because cutting or punching holes in the canvas—and especially Fontana's sole focus on this device—represented a radical gesture, but also because many perceived it as a shift to another medium and a break with the artist's previous practice as a sculptor. "Laughter that went on for years!" Fontana recalled the reaction. "People asked me, 'What are you doing, anyway? You of all people, Lucio, an excellent sculptor ...' For them, I was good before and an ass afterwards. And I managed to participate in the [1950 Venice] Biennale and pull the wool over the commission's eyes, because actually I had been invited with sculptures! But I didn't breathe a word, and went to the Biennale with 20 perforated canvases. You can imagine the reaction: 'These are not sculptures at all, they're paintings!' ... For me, they are perforated canvases that represent sculpture, a new fact in sculpture."

"You can say whatever you like about the holes. But a new direction in art is going to emerge purified from them (Giotto told me this in Padua, and Donatello confirmed it)."
LUCIO FONTANA, 1953

8

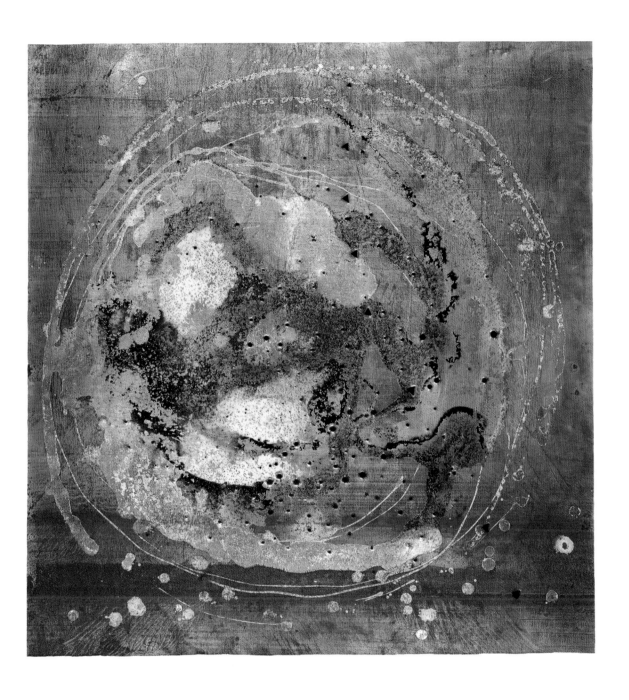

Concetto spaziale, 1952
Mixed media on sheet metal, 65 x 60 cm
Milan, Fondazione Lucio Fontana

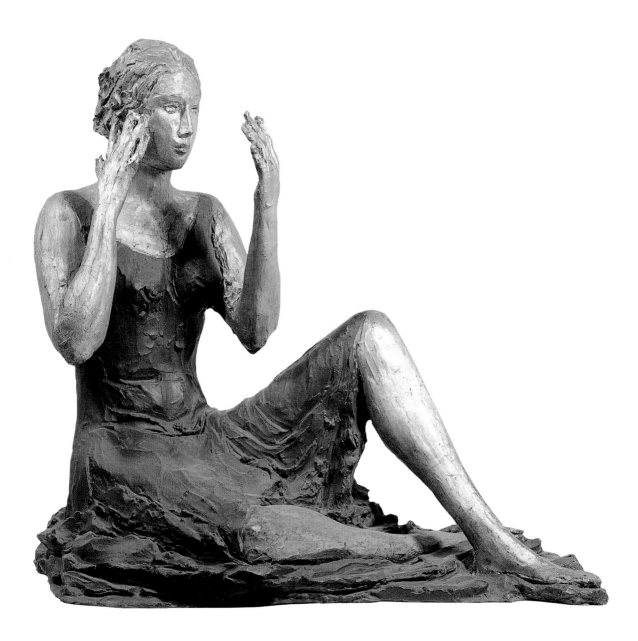

"A taste for influences"

Fontana's art is largely associated with a single gesture, an association he himself continually encouraged from the emergence of his first perforated canvases in 1949. In fact, his oeuvre is so diverse in terms of motifs and formal means that at first glance it is hard to believe that it is from a single artist's hand. This is well illustrated by two sculptures from the year 1934. The first is figurative: *Signorina seduta* (Seated Young Woman, p. 10), a polychromed plaster portrait of Jole Fontana, the artist's sister-in-law. The second is *Scultura astratta* (Abstract Sculpture, p. 19), a piece in tinted cement whose surface evinces engraved graphic markings. Two works, the one figurative and comparatively traditional, the other tending to an avant-garde, experimental abstraction of a kind that prompted contemporary critics like Raffaello Giolli to ask, "Is this sculpture or painting?"

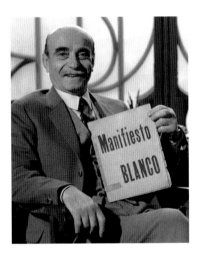

Lucio Fontana holding the *Manifiesto Blanco*, 1965

In view of this baffling concurrence of contrary styles, the art historian Isabella Amaduzzi, with reference to Fontana's work of the 1930s, recently noted its "disconcerting variety." This judgment reflects the widespread expectation that every artist should have a recognizable "touch," which serves both as a guarantee of the "authentic" expression of an artist's identity and as a reliable trademark on the art market. Fontana's contemporaries already noted his remarkable versatility and attempted to explain it. Edoardo Persico, architect and author of the first monograph on the artist, published in 1936, boiled the case down to Fontana's special "taste for influences," citing French author André Gide's statement that, "Whoever fears influences and avoids them, tacitly admits to his poverty of soul." As Persico explained, "Viewed from the outside, Fontana may appear to be a highly complicated and inconsistent artist. The ease with which he submits himself to all styles, his capacity for continual change, might well surprise us, as if we were confronted by a juggler." Interpreting this versatility by reference to the German sociologist Georg Simmel (1858–1918), whose writings were widely disseminated in Italy at that period, Persico traced it back to the artist's "inner turbulence, which communicates itself immediately, just as it is experienced, into the work; or better, which continues in the work." Simmel's description, however, taken from a lecture of 1918, was made with an eye to Expressionist art, and it was certainly over-simplifying things to attribute Fontana's "taste for influences" to a special "inner turbulence" alone. On the contrary, the biographical, his-

ILLUSTRATION PAGE 10:
Signorina seduta (Seated Young Woman), 1934
Polychromed plaster, 84 x 103 x 83 cm
Rome, private collection

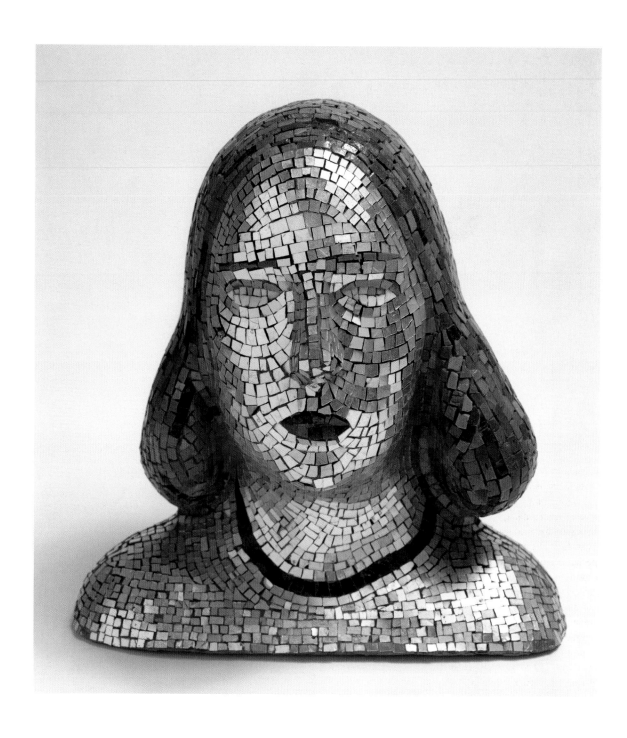

Ritratto di Teresita (Portrait of Teresita), 1940
Polychrome mosaic, 34 x 33 x 15 cm
Milan, Fondazione Lucio Fontana

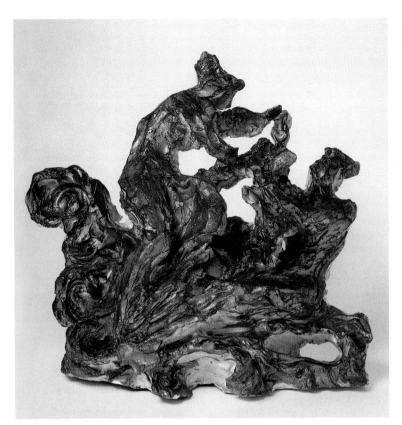

Donne sul sofà (Women on a Sofa), 1934
Polychromed plaster, 40 x 43 x 20 cm
Rome, Argan Collection

torical and cultural facets of this phenomenon were just as diverse as
Fontana's artistic production.

Lucio Fontana was born in 1899 in Rosario de Santa Fe, Argentina. His
father, Luigi Fontana, who had emigrated from Italy to Argentina in 1891,
was a sculptor who was much in demand for stately monuments and funer-
ary statues. His uncle, Geronzio Fontana, was partner in a local firm that
specialized in stucco ornament. After his parents' separation and his father's
second marriage, Lucio was sent to Italy in 1905 to stay with relatives in
Varese and attend school there. As an adolescent he attended a building
trades school in Milan, where his family had in the meantime returned;
after an intermission for military service in World War I, Fontana took his
engineering degree in 1918. In parallel with his education, he had already
begun to assist in his father's workshop. In 1920 he began art studies at the
Accademia di Brera in Milan, which were interrupted when his family
returned to Rosario de Santa Fe in 1922. In the 1920s the Argentine town
experienced an economic and cultural boom, thanks largely to Italian
immigrants, which made it a center of attraction for artists and architects.
Fontana initially worked in his father's business before establishing his own
sculpture workshop in 1924; that same year, he won his first competition, for
a memorial plaque to the French chemist Louis Pasteur. The year 1925 saw his
first participation in a group exhibition, the "VIII Salón de Bellas Artes," in
Rosario de Santa Fe. The first entry in his catalogue raisonné dates to the
following year: the sculpture of a strongly abstracted nude (p. 15), which

"I don't claim to have invented anything.
I admit that the Futurists prompted me—
time, space, etc."
LUCIO FONTANA, 1968

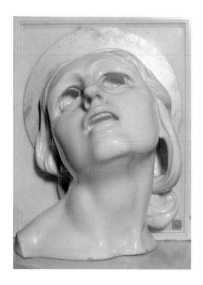

Adolfo Wildt
Santa Lucia, 1926
Marble and bronze, height 54.8 cm
Forlì, Musei civici

El Auriga (The Charioteer), 1928
Plaster
destroyed

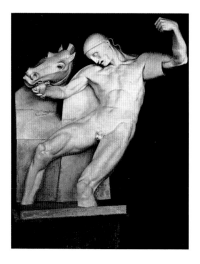

reflects the influence of Umberto Boccioni (1882–1916). In the 1910s, Boccioni was one of the leading representatives of Italian Futurism, and his sculptures and manifestoes were to prove one of the most lasting of the many influences on Fontana's art. That same year, Fontana submitted a work in an entirely different style to a competition for a monument to the educator Juana Elena Blanco. His design for a naturalistic group of figures, a seated woman with two children, garnered first prize and was cast in bronze the following year. In addition, Fontana did a flourishing trade in marble, imported from the renowned Carrara quarry. "Everything was going extremely well," Fontana was quoted in 1959 in the Italian magazine *Gente.* " If I had carried on, I should be a multi-millionaire today. Instead, I gave it all up from one day to the next and came to Milan to learn sculpture. I enrolled in the Accademia di Brera at the age of nearly 30 and began to study like crazy under the guidance of the great master of marble, Adolfo Wildt. My teacher regarded me as his best pupil" (p. 14 top). With his decision to study sculpture, Fontana left the path his father had planned for him. Luigi, starting from scratch, had built himself a secure position as an artist who worked to order, and he envisaged an equally successful career for his son in the field of architecture or decorative sculpture. The extensive correspondence between the two attests to the tensions that resulted from Lucio's attempts to work as a freelance artist with insecure financial prospects.

Fontana received his final diploma in 1930 for a sculpture done in 1928, *El Auriga* (The Charioteer, p. 14 bottom). The piece clearly reflected Wildt's influence, and attested to Fontana's superb mastery of materials—a mastery he would later look upon as a form of submission, a "slavery to matter" he attempted to overcome. The same year as he received his diploma, Fontana abandoned the academic style. In a 1943 interview with the Argentine newspaper *La Nacion*, Fontana maintained that Wildt hoped he would become his successor. "But hardly had I left the academy," said Fontana, "when I took a big pile of plaster, gave it the approximate shape of a seated man, and then poured tar over it. Just like that, in a violent reaction. Wildt, of course, was quite horrified."

With this gesture, Fontana left behind not only his academic training but also a tendency in contemporary art known as "Novecento" (Twentieth Century). This movement rejected the experiences of early twentieth-century avant-gardes such as Cubism and Futurism, and advocated a "return to order," to earlier Italian traditions, such as the art of the Etruscans and Early Renaissance. In the eyes of Edoardo Persico, Fontana's plaster sculpture *Uomo nero* (Black Man, p. 17) with its coarse blocky volumes was "the first sign of liberation: a somewhat naive and arbitrary primitivism." Over the following years, Fontana would develop this experimental "primitivism" in a series of painted terracotta reliefs, such as *Figure nere* (Black Figures, p. 16), a male and female silhouette superimposed one behind the other at two levels in the relief. These works, too, combined painting and sculpture—an ambition which echoed Fontana's origin from a family of artists who worked in both fields: "My father was a good sculptor, and my desire was to be one, too; I also would have liked to be a good painter like my granddad, but I realized that these specific terminologies of art were not for me, and I thought of myself as an artist of space [artista spaziale]," Fontana was quoted in an anthology of artists' statements compiled by Leonardo Sinisgalli in 1954.

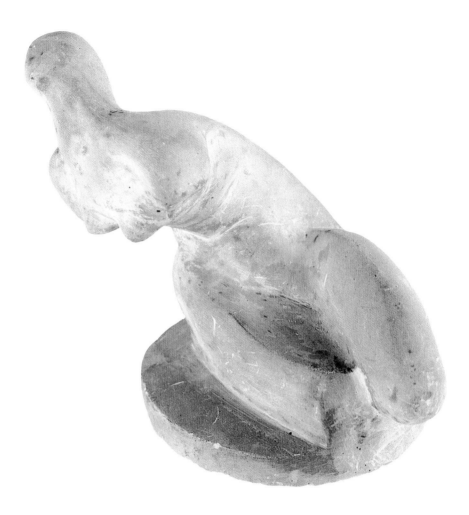

Nudo (Nude), 1926
Plaster, 17.5 x 21 x 14 cm
Milan, Fondazione Lucio Fontana

Fontana would make no final distinction between painting and sculpture, abstraction and figuration, avant-garde fine art and popular kitsch. In 1929, through the artist Fausto Melotti, he had met Edoardo Persico, an architect associated with the Rationalist movement. As head of the Milan Galleria del Milione, Persico furthered abstract art, which had few forums in Italy at the time. Fontana began to exhibit regularly at the gallery in 1931 (p. 18). With Melotti and others he joined the Parisian artists group "Abstraction-Création" in 1935, and participated that same year in the "Prima mostra collettiva di arte astratta italiana" (First Group Exhibition of Italian Abstract Art) in Turin.

In parallel, Fontana explored the potentials of terracotta with colored glazes and of other traditional techniques, such as gilded mosaic. His portrait bust of his future wife, Teresita Fontana (p. 12), appears especially innovative in view of the fact that mosaic was generally reserved for the decoration of large, flat surfaces such as floors and ceilings. Fontana's penchant for shiny, light-reflecting glazes and gildings corresponded to his fascination with light as a constitutive element of sculpture: "The material is only a pretext for containing light," he wrote to the architect Giò Ponti in an undated letter.

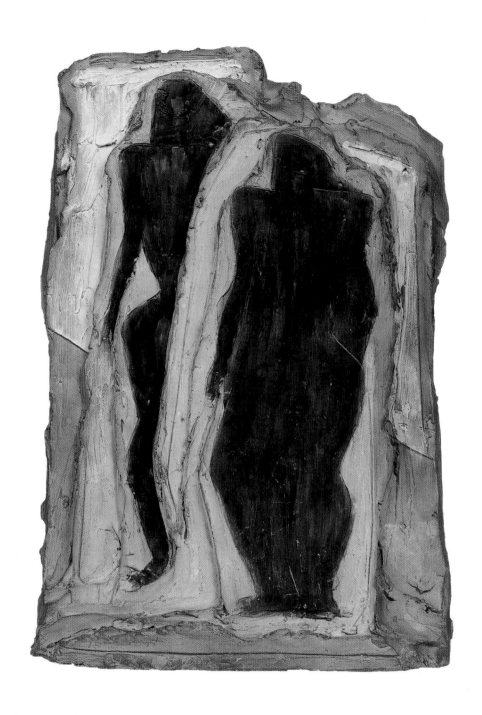

Figure nere (Black Figures), 1931
Polychromed terracotta, 41 x 30 x 12.5 cm
Milan, Fondazione Lucio Fontana

The broad range of Fontana's motifs extended from still lifes through neo-expressionist depictions of animals, such as *Cavalli* (Horses), to figure groups inspired by Baroque sculpture, such as *Donne sul sofà* (Women on a Sofa, p. 13). Filippo Tommaso Marinetti, who in 1909 had become co-founder of the first Italian avant-garde movement in the twentieth century with the *Manifesto of Futurism*, praised Fontana in 1938 in his manifesto *Ceramica e Aeroceramica* (Ceramics and Aeroceramics). At the same time, Fontana vociferously defended himself against any association of his ceramics with the arts and crafts, a classification that had been current ever since the flourishing of terracotta sculpture in the Italian Renaissance: "I am a sculptor, not a ceramicist," he emphasized in a 1939 article for the journal *Tempo*. "I have never thrown a plate on a wheel and never painted a vase."

Fontana's work from 1927 to 1940 was done under the conditions of fascist dictatorship in Italy, which had been rung in with Benito Mussolini's 1922 "March on Rome." Before that year was over, fascist cultural policy had led to the organization of artists in a "Sindacati fascisti Belle Arti" (Fascist Artists Union), membership in which was the precondition for participation in official national and international exhibitions such as the Venice Biennale, the Milan Triennale, and the Rome Quadriennale. At the same time, the regime began to further art on a massive scale by awarding prizes and granting public commissions. It was a principle of fascist policy to admit artistic tendencies of various kinds, although in practice the assigned subject matter and formal restrictions increasingly forced adherence to the regime's propaganda aesthetic." On the one hand, it was a matter of binding the intellectuals to the regime, to prevent the formation of a cultural opposition; on the other, there was the necessity to develop artistic and cultural forms that were easily understandable and could find a consensus among the broad public," Guido Armellini characterized this dual strategy in 1980.

One of the favorite motifs of official art was Victoria, the Roman goddess of victory. Although Italy had belonged to the victorious powers after World War I, the peace treaties disappointed Italy's expansionist expectations, which included the German colonies in Africa, Fiume and Dalmatia. As a result, the myth of *Vittoria mutilata,* or mutilated goddess of victory, found a widespread acceptance that was soon exploited by the fascists. This explains the frequent presence of statues of Victory in national sculpture competitions and exhibitions, such as the Venice Biennales of 1928 and 1930 and the VI Milan Triennale in 1936. As early as 1929, while still a student, Fontana had presented a first interpretation of the subject and showed it at the 1930 Venice Biennale: *Vittoria fascista* (Fascist Victory, p. 20 bottom), a bronze of a nude winged female figure of rather childlike proportions who, apparently about to leap into the air, holds a sort of victory wreath in her left hand. Much more noble in character was the commission for the "Salone della Vittoria" (Hall of Victory), which Fontana executed in collaboration with the architects Giancarlo Palanti and Edoardo Persico, and the painter Marcello Nizzoli, for the VI Milan Triennale in 1936. On two pedestals at the end of the pilaster-lined hall stood Fontana's monumental, over five-meter-high-group of white figures: a slim, almost incorporeal long-gowned Victoria with two rearing horses on the pedestal behind her (p. 20 top). Since the hall was used, among other things, as a festive setting for Mussolini's speeches, a quotation of his was engraved on the pedestal of the Victoria figure. An important feature of the room's dramatic staging was an illumination of the pilasters from behind. The light

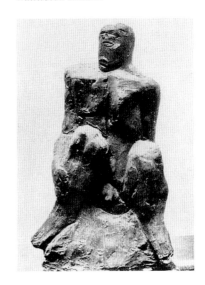

Uomo nero (Black Man), 1930
Plaster, finished in black, height 130 cm
Whereabouts unknown

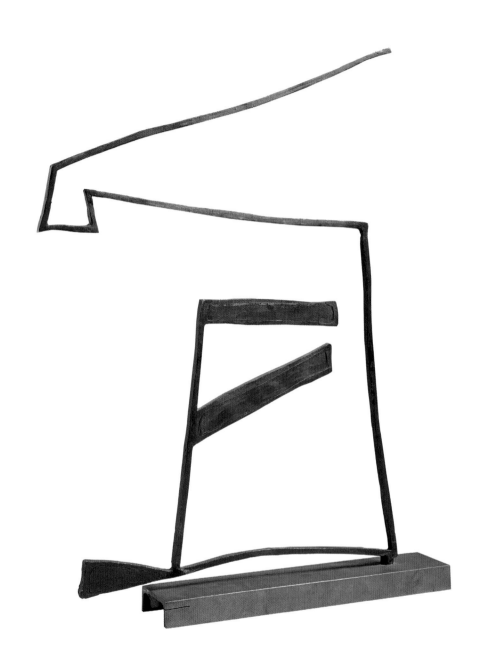

Scultura astratta (Abstract Sculpture), 1934
Polychromed iron, 62.5 x 50 x 7 cm
Turin, Galleria Civica d'Arte Moderna e Contemporanea

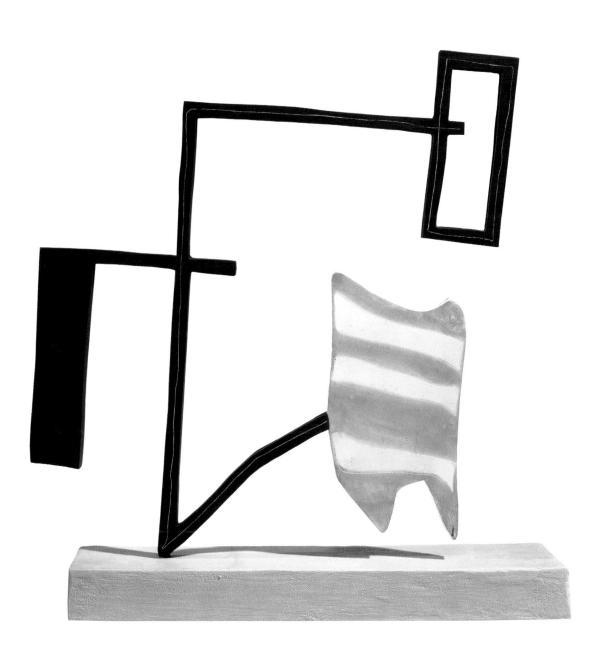

Scultura astratta, 1934
Polychromed plaster, 59 x 54 x 2 cm
Private collection

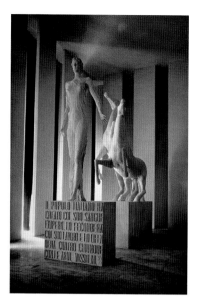

Vittoria (Victory), 1936
Executed for the "Salone della Vittoria,"
VI Milan Triennale
Plaster, height approx. 500 cm
destroyed

Vittoria fascista (Fascist Victory), 1929
Bronze, height 120 cm
Milan, private collection

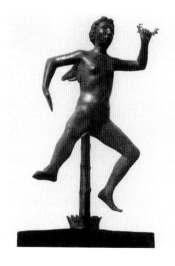

rays refracted around their edges, appearing to negate the massiveness of the architecture. One contemporary critic stated that entering the hall was like "entering a painting, or a poem … The sudden immersion in the white makes us lose our very sense of weight and every yardstick of measurement."

In spring 1940, shortly before Italy entered the Second World War on 10 June, Fontana returned for six years to Argentina. His decision to bow to his father's wish and assist in the family business had been repeatedly considered and rejected during the 1930s, as Fontana's letters indicate. He always emphasized that he preferred the risk of freelance art to the constraints of commissioned work: "In Italy," Fontana wrote to his father on 21 May 1939, "my artistic struggle with its disappointments keeps me alive, and I feel the joy of being an artist, while in Argentina I couldn't manage that." Still, a return to Argentina promised dual prospects: "—if I came to Rosario, I might be able to work and at the same time establish a strong movement in modern art with the Rosario artists—they would see how things could be moved," he had explained to his father in a previous letter of 1935.

Fontana in fact pursued this dual strategy during his second—and final—stay in Argentina. On the one hand, he developed great ambitions in the field of commissioned art and competitions. In a November 1949 letter to the author and publisher Giampiero Giani, he envisioned "letting myself go in B[uenos] Aires, to win all the country's first prizes across the board." Yet his optimism faltered when he failed to win a competition and his father cut off his allowance. This may have been one reason for Fontana's return at this point to a more conventional style, as in the plaster sculpture *La bella Italiana* (The beautiful Italian Woman, p. 21), shown in a one-man exhibition at the Müller gallery in Buenos Aires. In addition—probably with an eye to escaping the provincial cultural climate of Rosaria de Santa Fe—Fontana taught interior decoration at the Academia de Bellas Artes Manuel Belgrano from 1943–45, and in 1945 worked as a ceramicist in the Cattaneo shop.

At the same time, Fontana pursued his idea of founding a "strong movement in modern art" in Buenos Aires. In 1946 he joined Jorge Romero Brest, Jorge Larco and Emilio Pettoruti to establish a private art school, "Altamira," named after the famous Early Stone Age cave paintings near Santander in northern Spain. The school was funded by Gonzalo Losada, an exiled Spanish intellectual. Fontana taught sculpture there. The Academia de Altamira became a gathering place and exhibition space for the young, avant-garde artists group Madí, which had emerged from Tomás Maldonado's "Movimento d'Arte Concretista" (Movement of Concretist Art). It was here, in 1946, that the *Manifiesto Blanco* (White Manifesto) was penned.

It might be argued that not only Fontana's work up to the 1940s, but also the *Manifiesto Blanco*, was eclectic and characterized by "a taste for influences." The demands and ideals it advanced were highly inconsistent, perhaps partly owing to its multiple authorship. On the one hand, the manifesto appealed to scientists around the world "to devote part of their research to the discovery of the plastic substance of light and musical instruments which will enable the development of a four-dimensional art," declaring that conventional art genres had become outmoded: "We live in the age of physics and technology. Painted cardboard and erected plaster no longer have any justification to exist." Instead, the distinctions between the different arts must be overcome: "We require a more comprehensive art that corresponds to the needs of the new spirit." Pointers, said the manifesto, could be found in Baroque art, in

which the figures began to emerge from the plane and appeared to enter the surrounding space. With statements such as, "There is no quiet life any more. The concept of speed is a constant in human life," the authors of the *White Manifesto* paid their respects to the manifestoes of Futurism.

Yet while demanding that art do justice to the technological age, the authors continued to extol nature and advocate a "reconstitution of the primal human state": "The new art derives its elements from nature. … The love of nature compels us to copy it in its processes." On the other hand, "rationalistic artists" were roundly rejected, since they proceeded "from false premises"— this perhaps partly in reaction to Fontana's collaboration with representatives of Rationalistic architecture under Mussolini's regime.

The *White Manifesto* is generally thought to have been conceived by Fontana with the assistance of his students at the Academia de Altamira. It was supposedly authored by Bernardo Arias, Horacio Cazeneuve, and Marcos Fridman, who signed it together with Pablo Arias, Rodolfo Burgos, Enrique Benito, César Bernal, Luis Coll, Alfredo Hansen, and Jorge Roccamonte. It is not clear why Fontana was not among the signatories. At any rate, as he told the critic Carla Lonzi in 1967, the original plan was to leave the manifesto unsigned, and it was signed only at the behest of the students involved.

In April 1947, Fontana returned to Italy, bringing the ideas of the *Manifiesto Blanco* along with him. The favorable cultural climate in Argentina, from which the manifesto emerged, had been suppressed when Juan Domingo Peron came to power in 1946. When it reached European soil, the *White Manifesto* formed the seed of a series of further manifestoes, written and launched with changing authorship in the 1940s and '50s with an eye to establishing "Spatialism"—not without underscoring Fontana's role as "founder and initiator" of the movement, as stated in the 1950 *Proposal for a Set of Rules.*

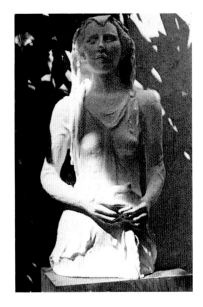

La bella italiana
(The beautiful Italian Woman), 1941
Plaster, height approx. 100 cm (?)
Santa Fe, Museo Provincial de Bellas Artes
"Rosa Galisteo de Rodriguez"

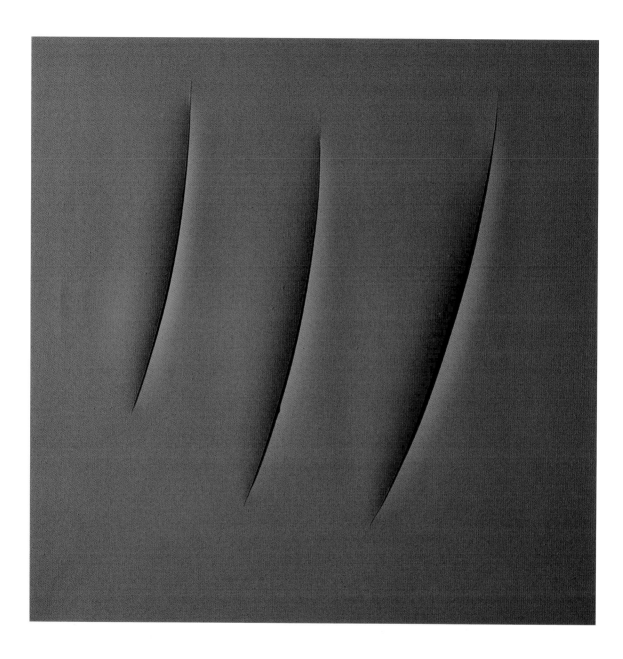

"Spatialism"—The Emergence of a New Direction in Art

When Fontana returned to Milan in April 1947, he found his former neighborhood —including his studio and the works he had left behind there in 1940—destroyed by Allied bombs. His reputation in Italy, as the curator Sarah Whitfield has remarked, "rested in part on the sculptures he had made for the trade fairs and exhibitions promoting Mussolini's Italy of the 1930s, a period that in 1947 nobody wished to remember." Even though the political and cultural debates about the Mussolini era in postwar Italy were more complex than this statement would suggest, the loss of a large part of his early oeuvre was probably one of the reasons why Fontana came to be perceived essentially as a postwar artist. "As far as he was concerned," Whitfield states, "the story of his career was the story of his last 20 years."

The first perforated canvases, done in 1949 (pp. 6, 8), were viewed as a turning point not only by the artist, but by many of his commentators. For a number of authors, they marked the inception of postwar art in Italy. As Jole de Sanna noted in 1989, "A typically iconoclastic gesture was performed by Lucio Fontana's hand as it perforated the canvas (1949). Yet in this very act lay the origin of the new Italian art." As Fontana's own statements from the period indicate, he felt that a reorientation was necessary to do justice to the experiences of the war and interwar periods. Abstraction apparently held clear priority in this desire for a new beginning. As Fontana wrote on 25 March 1949 to Paolo Edelstein, "Art does not develop, because if it did, Greek art and the art of the Renaissance would have sufficed to lead humanity to perfection. In truth, art served and still serves propaganda purposes. For every ideal there is a triumphal arch, monuments to generals and heroes, sculptures commemorating battles or gods. Propaganda practiced by artists, presented to us as works of art. Yet if every artist were inspired by the beauty of a pure, abstract art, this would serve the welfare of the community." With his first *Buchi*, Fontana apparently associated the idea of leaving the rhetorical—and therefore politically instrumentalizable—aspect of art behind. "A butterfly in space excites my imagination; liberated from rhetoric, I lose myself in time and begin my *Buchi*," he wrote in an anthology of artists' statements published in the mid-1950s.

Nevertheless, like the previous phases of his activities between free and commissioned art, Fontana's work of the postwar years cannot be reduced to

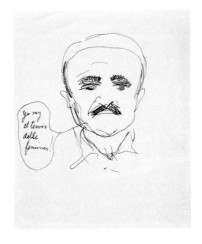

Self-portrait, 1947
Black ink on paper, 17.4 x 16 cm
Milan, Fondazione Lucio Fontana

Long before his perforated and incised canvases prompted the English daily *Independent* to ironically nickname him "The Ripper" in 1988, Fontana characterized himself in a self-portrait of 1947—the year of his final return from Argentina to Italy—as the "terror of women."

ILLUSTRATION PAGE 22:
Concetto spaziale, Attese
(Spatial Concept, Expectations), 1959
Watercolor on canvas, 91 x 91 cm
Japan, location unknown

Scultura spaziale (Spatial Sculpture), 1947
Plaster, finished in black, 59 x 50 cm
Casale Monferrato, private collection

ILLUSTRATION BELOW:
Pagliaccio (Clown), 1948
Colored ceramic, 70 x 37.5 x 24 cm
Milan, private collection

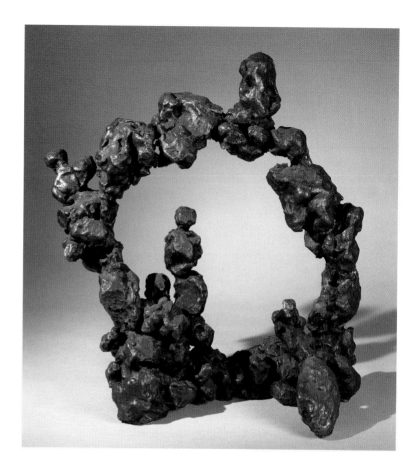

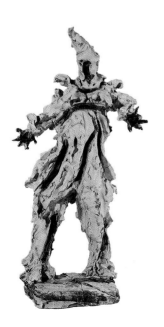

a simple common denominator. The first pieces he did after arriving in Italy in April 1947 were executed in the Mazzotti ceramic workshops in Albisola. These included figurative ceramic sculptures with deeply fissured surfaces, such as the ghostly *Pagliaccio* (Clown, p. 24 bottom), which linked up with prewar works, but also innovative formal experiments, like a circular accumulation of amorphous, seemingly molten lumps of plaster from which a single, off-center, figure-like configuration projects (p. 24 top). That same year, 1948, Fontana produced the earliest works which are now entitled *Concetto spaziale* (Spatial Concept), a title he would apply to virtually his entire production over the next two decades. As the art historian Giovanni Lista has pointed out, the term *Concetto spaziale* goes back to the Futurist artist Fillia (actually Luigi Colombo, 1904–1936). Fillia applied this designation in 1932 to a painting of his that belonged to the *Aeropittura* (aerial painting) phase of Futurism. In terms of motif as well, a link with Futurism is seen in Fontana's series of *Concetti spaziali* with perforations that recall spiral nebulae or constellations. The painter and sculptor Giacomo Balla, an artist Fontana much admired, was an amateur astronomer who was interested in the dynamism of heavenly bodies. Spirals and vortices, "flight paths" and lines of velocity featured frequently in the painting and sculpture of Futurism. Fontana, for his part, evoked the incessant motion not only of planets

and stars, but of the elementary particles of matter. "For the first time, the physics of this period [the Baroque] viewed nature as a dynamic thing. People recognized that motion was an intrinsic principle of matter, an insight that rendered the universe understandable for the first time," stated the *Manifiesto Blanco*. This insight was reflected in the deep agitated whorls in the surface of a cubist ceramic sculpture Fontana made in 1949 (p. 25 bottom).

Fontana began to propagate "Spatialism" as an art movement that adopted and modified Futurist ideas as early as the end of 1947. On 25 November of that year he wrote to Tullio d'Albisola, "Tomorrow we are holding the first 'spatial' meeting. It will be a huge gathering and I hope to get the manifesto together soon. There are people in Milan who were already interested, all that was needed was to form a 'group'." This "group," whose membership would vary during the late 1940s and early 1950s, initially included the art dealer Carlo Cardazzo, the author, critic and publisher Giampiero Giani, the philosopher and painter Beniamino Joppolo, the philosophers and critics Giorgio Kaisserlian and Antonio Tullier, and the author Milena Milani. Its influence remained limited largely to northern Italy. With its roots in Futurism, an early twentieth-century avant-garde movement, "Spatialism" was one of those postwar artistic phenomena for which the sociologist Peter Bürger coined the term "neo-avant-garde" in the 1970s. Unlike its historical model, "Spatialism" sang no praises of violence and destruction—especially of the

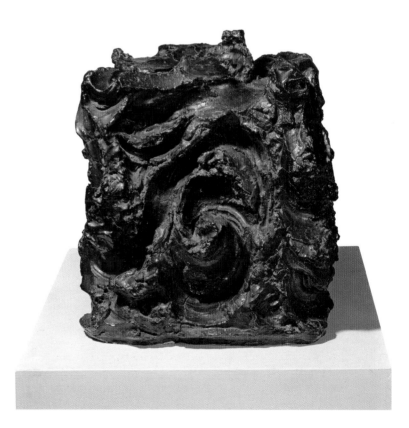

Ceramica spaziale (Spatial Ceramic), 1949
Colored ceramic, 60 x 60 x 60 cm
Paris, Centre Georges Pompidou,
Musée National d'Art Moderne

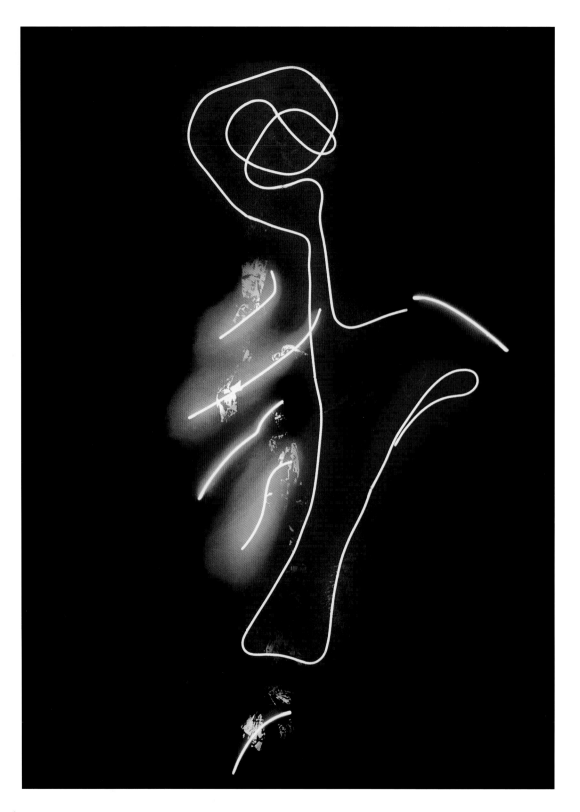

Ambiente nero (Black Ambience), 1948–49
Design for *Ambiente spaziale a luce nera*
(Spatial Environment with Black Light)
Colored Indian inks on photograph, 21 x 17.5 cm
Milan, Fondazione Lucio Fontana

ILLUSTRATION PAGE 26:
Soffitto spaziale (Space Ceiling), 1954
Breda-pavilion, XXXIII Milan Fair
Neon on painted surface
destroyed

Fontana's 1954 design for the ceiling of a cinema
in the pavilion of the Breda Company consisted
of a tentlike surface painted in colored lacquers
and fitted with curving neon tubing—a space-
related variant of l'Art informel in new technical
media.

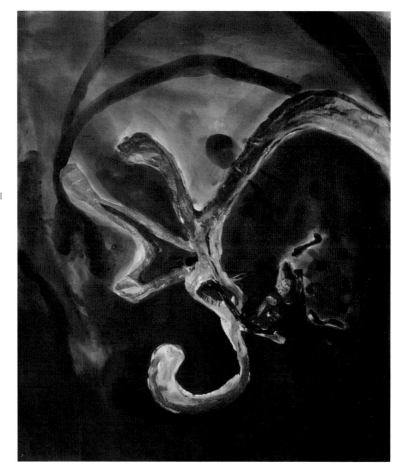

art of earlier eras—in its manifestoes. "We shall glorify war—that sole hy-
giene for the world," proclaimed the Futurists in their founding manifesto of
1909. "Set fire to the library shelves! … Divert the canals to flood the muse-
ums! … Tear the venerable cities down without mercy!" After two world
wars and sundry dictatorships had turned the Futurists' 1909 visions into a
cruel reality, the authors of the *Technical Manifesto of Spatialism* stated in
1951, as if
chastened, "The conquest of space and the atomic bomb urge mankind to
make preparations for protection." Nevertheless, Fontana left no doubt that
he viewed himself as a legitimate heir of Marinetti, Balla and Boccioni. In a
draft letter to Giampiero Giani in November 1949, he wrote, "The book *Paint-
ing and Sculpture of the Avant-Garde*, which began with Futurism, might
close with the *Ambiente spaziale* [Spatial Ambience], the logical consequence
of 50 [years] of contemporary art."

Fontana installed his first *Ambiente spaziale* in February 1949 in the Galleria
del Naviglio in Milan. It was an innovative installation with which "the spa-
tial polemic entered its active phase," as he wrote to a friend a month later.
Among the visitors to the *Ambiente spaziale a luce nera* (Spatial Environment

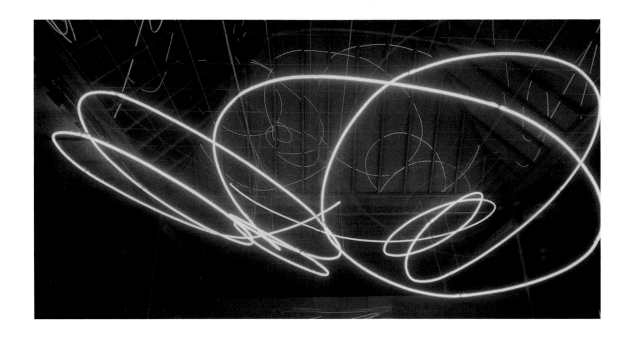

Struttura al neon per la IX Triennale di Milano
(Neon Structure), 1951
Neon tubing, diameter 18 mm, length 100 m
Reconstruction

Lucio Fontana and his *Struttura al neon*, 1959

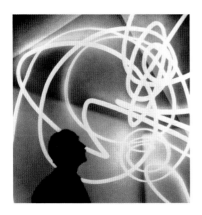

with Black Light, p. 27) was Guido Ballo, a critic who in retrospect felt reminded of a "poetically evocative lunar atmosphere." "You entered a sort of grotto," recalled Ballo, "in which the violet light between hovering and heavy forms—resembling prehistoric creatures—spirited you as if to the bottom of the sea and gave everyone a ghostly appearance. We had the feeling of being enclosed in a great piece of ceramics suffused with ultraviolet light. There were no boundaries anywhere; everything was reminiscent of precincts of the unconscious where space has no center point and no surface exists." The walls of the darkened gallery were partially covered with black cloth or painted black; from the ceiling hung an arrangement of organically curving elements of papier maché painted in fluorescent colors. The black light illumination made the painted shapes glow in the dark. In *Ambiente spaziale a luce nera*—whose week-long presentation was more of an event than an exhibition—the media of painting, sculpture and architecture merged in the ultraviolet light into a unity that also included the observer. With this conception, Fontana put into practice ideas contained in the *White Manifiesto* of 1946, excerpts from which were published in the exhibition catalogue: "Previously the division into separate art genres was necessary," it stated. "Today, this would imply a dissolution of their unity. We view this synthesis as the sum of individual phenomena such as color, sound, motion, time and space, which integrate themselves into a psycho-physical unity."

The event at Galleria del Naviglio triggered widespread and highly diverse reactions in the press, indicating its attractiveness as a spectacle. In view of the fluorescent colors gleaming in the black light, Raffaele Carrieri, critic of the newspaper *Tempo*, was put in mind of Fontana's contributions to the official exhibitions of the 1930s: "This luminous and agitated material charmed us," Carrieri wrote the day after the opening. "I recall his enormous horses in the Persico room at the second [sic] Triennale, as if it were a

natural spectacle. A glacier smashed by lightning"—apparently a naive reminiscence of the "Salone della Vittoria" of 1936 (p. 20 top). The illustrations to Carrieri's article included a photograph of a dancer who, according to the caption, "enlivened the mysterious stage setting." Evidently Fontana's installation was accompanied, for a time at least, by music and dance. The reviewer of the socialist paper *Avanti*! detected a utopian aspect in *Ambiente spaziale a luce nera,* an attempt to create an "ambience of colors and sounds" that were more harmonious than those of everyday life. Several critics associated Fontana's configurations with prehistoric forms. The elongated papier maché elements reminded Carrieri of a "fossil dinosaur" or the "spine of a mammoth." Lisa Ponti published her article for the journal *Domus* under the title "Primo graffito dell'età atomica" (First Graffito of the Atomic Age). In fact, various aspects of Fontana's earlier works came together in his first *Ambiente*: the imagery of his ceramics, which had made reference to marine and deep sea creatures, and the notion of a prehistoric cave as the original source of art, which had given the Academia de Altamira in Buenos Aires its

ILLUSTRATION RIGHT:
Self-portrait, 1940
Ink on paper, 29 x 22.5 cm
Varese, Crippa Collection

Picasso drawing a luminous trace in the air with a flashlight.
Vallauris, Madoura ceramics workshop, 1949

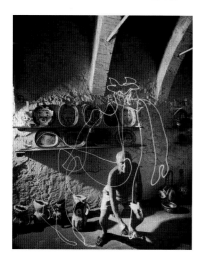

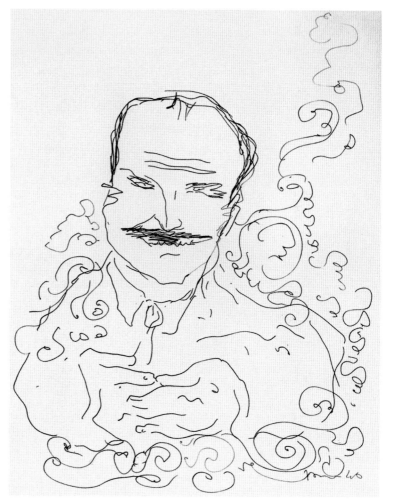

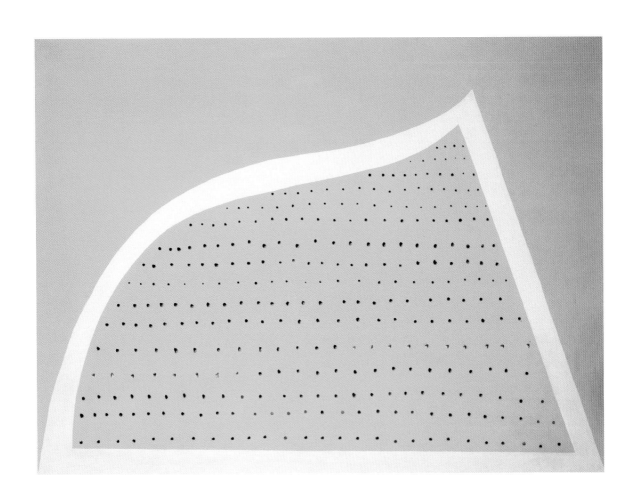

Concetto spaziale, 1960
Oil on canvas, 125 x 165 cm
Rome, private collection

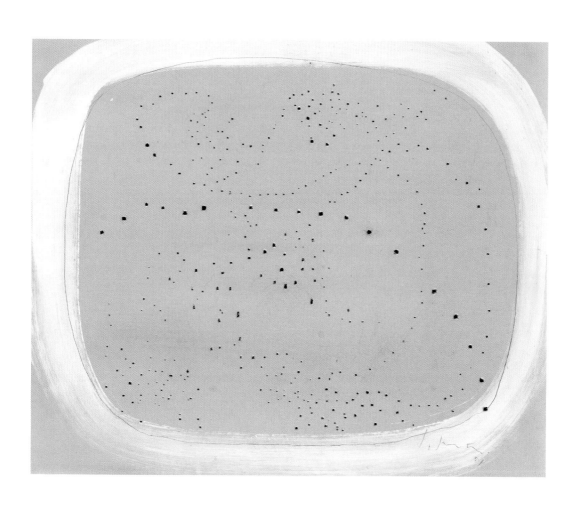

Concetto spaziale, 1959
Oil and pencil on canvas, 46 x 55 cm
Milan, Fondazione Lucio Fontana

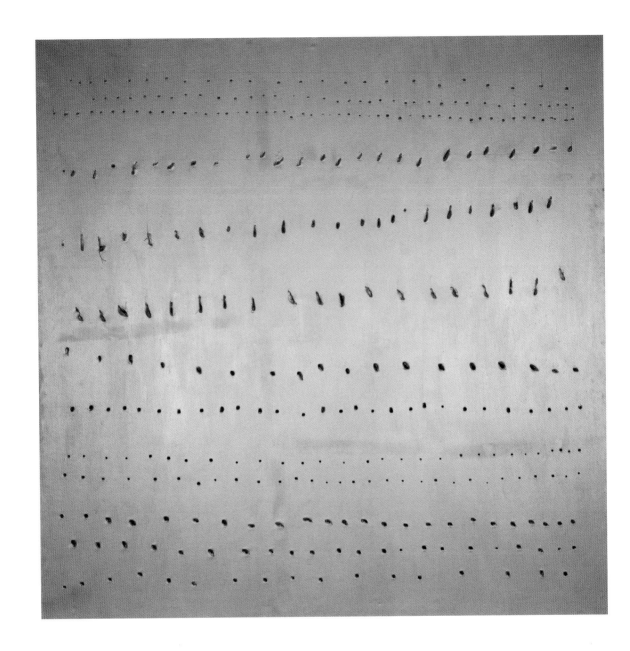

Concetto spaziale, 1959–1960
Oil on canvas, 200 x 200 cm
Seoul, Ho-Am Art Museum

name. In view of the declaration in the *Manifiesto Blanco* that the "original human state" of the "prehistoric age" must be revived, Fontana's *Ambiente spaziale a luce nera* can be viewed as an attempt to put this into three-dimensional practice. However, the experimental exhibition seems to have left Fontana himself with the ambiguous feeling of having done something whose equivocality surpassed his conscious intentions. In a draft letter to Giampiero Giani, he wrote in November 1949: "The *Ambiente spaziale* is the Philosopher's Stone, too simple and too difficult; sometimes I have the impression of having conceived something that is superior to intelligence, or crazy or exalted. … The *Ambiente spaziale* gave me the sensation of a discovery, but today I have terrible doubts."

The rubric *Ambienti*, or space-related installations, also covers those Fontana designs which were executed in collaboration with others, especially architects and interior designers. Such forms of cooperation were not least the result of the technical demands made by new materials, as Fontana once remarked: "Sculpture in light—you can't illuminate marble, you can't illuminate bronze. Yet back then there were neon tubes. So I decided on neon … For an artist, neon is hard to handle. Collaboration with technicians and engineers is necessary." One of the most compelling examples of this collaboration is the artist's *Struttura al neon* (Neon Structure, p. 28), a joint project with the architects Luciano Baldessari and Marcello Grisotti for the IX Milan Triennale in 1951. Above the central stairwell of the exhibition

"When I began using the stones, I wanted to find out whether I could expand the dimension, but, on the contrary, it was a step backwards, you know, because you can make mistakes when you think you're advancing; I thought I could increase the effect of light and motion with the stones."
LUCIO FONTANA, 1967

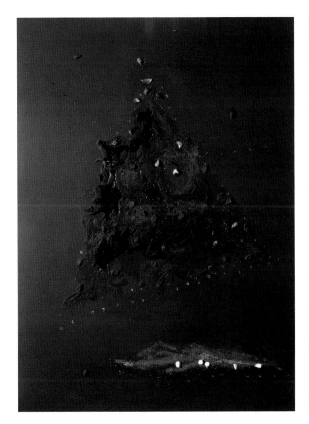

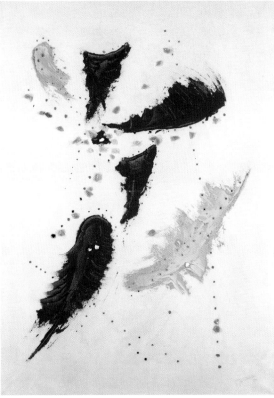

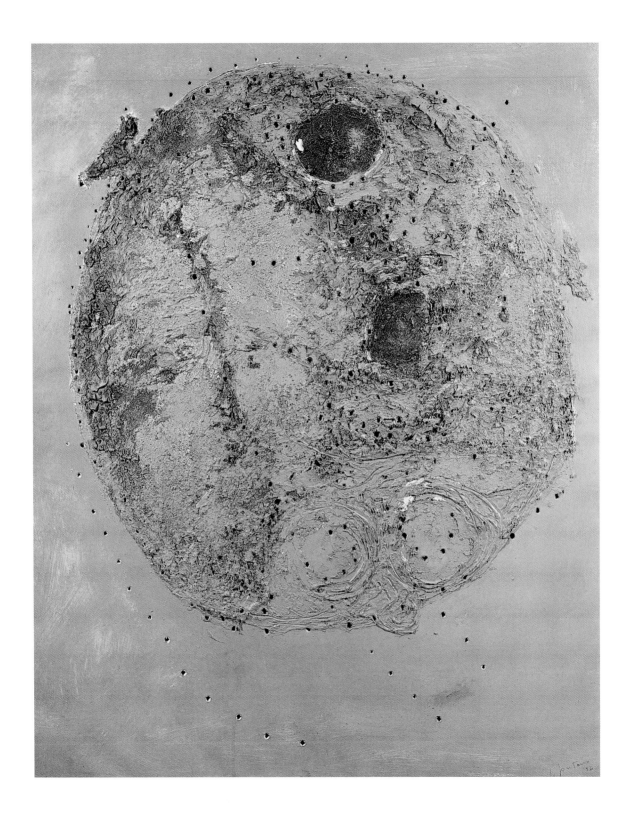

Concetto spaziale, 1955
Oil, mixed media and pieces of glass
on composition board, 124.5 x 90 cm
Milan, private collection

ILLUSTRATION PAGE 34:
Concetto spaziale, 1956
Oil, mixed media and sequins on canvas,
98 x 78 cm
Stuttgart, Edzard und Helga Reuter Collection

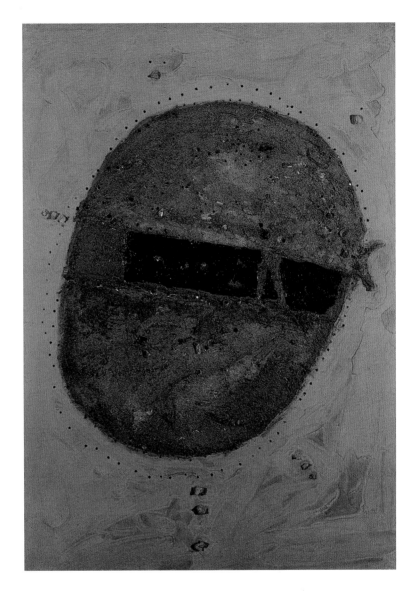

building, an over one-hundred-meter-long neon tube in the shape of a
sweeping arabesque was installed. Affixed to the ceiling at only a few points,
it appeared to hover weightlessly in space. The neon light transcended the
physical limits of the arabesque to suffuse and transform the entire space.
Its hybrid character between autonomous sculpture, lighting fixture, and
part of an architectural setting, corresponded to the purpose of the Triennale.
Rather than being an art exhibition in the narrower sense, it was devoted to
applied art, architecture, and industry.

Comparable approaches to a space-related sculpture in light are found as
early as the 1920s, as in László Moholy-Nagy's famous *Light-Space Modulator*
(1922–30), or, in Argentina in the latter half of the 1940s, in the work of
Georges Vantongerloo and Gyula Kosice, with which Fontana was familiar.

35

Fontana translated such earlier projects onto a monumental scale, while recurring to his own graphic vocabulary, in which arabesques played a role— as in a self-portrait of 1940 (p. 29 right). In designing his neon arabesque, Fontana had an eye for yet another, dominating artist figure: Picasso. Fontana "was fond of deliberately subverting the work of artists more prominent than himself," remarked art historian Anthony White in this connection. An important stimulus for the neon work came from a photograph by Gjon Mili that appeared in the March 1950 issue of the Milan art journal *AZ: arte d'oggi* (p. 29 left). It showed Picasso wielding a flashlight and drawing a luminous trace through the air, which was captured on the negative in a long exposure. Such performances with light drew the attention of Italian print media around 1950. In April of that year, for instance, the journal *Tempo* published several works by other artists in this technique. The use of the term "Arte spaziale" in this context displeased Fontana, because he wished to establish it as the exclusive label for the loose grouping of "Spaziali" artists. His spectacular, large-scale neon arabesque in the foyer of the Triennale accordingly took on the character of a publicly highly effective statement. In

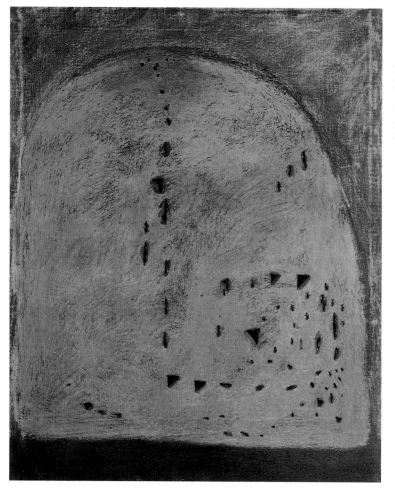

Concetto spaziale, 1954
Pastel and incisions on canvas, 82 x 65 cm
Milan, private collection

Between 1954 and 1958 Fontana devoted himself to the *Gessi* series, works in frequently dark, earth-colored pastel on perforated canvases. Their biomorphic motifs alluded to natural processes such as fermentation and cell division. Fontana used to ironically refer to their bulging forms as "panettoni," because they recalled the Italian yeast cake of that name.

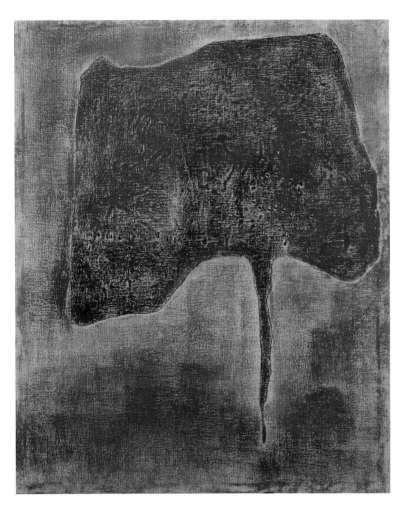

Concetto spaziale, 1957
Pastel and collage on canvas, 100 x 81 cm
Pully/Lausanne, Asher Edelman Foundation

Concetto spaziale, Forma
(Spatial Concept, Form), 1957
Bronze, height 150 cm
Cologne, Museum Ludwig

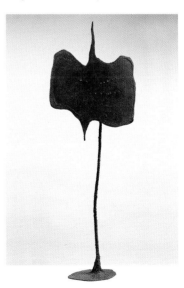

addition, Fontana took advantage of a convention held in conjunction with the exhibition to publish yet another manifesto: the *Technical Manifesto of Spatialism*, a title that alluded to the Futurist *Technical Manifestoes* published in the 1910s. The *Technical Manifesto of Spatialism* had recourse to certain ideas advanced in the *White Manifesto*, such as the pioneering character of the Baroque conception of space and time, and of the "plastic dynamism" of the Futurists. In keeping with the Triennale's concept, Fontana placed special emphasis on the revolutionary architectural potential of reinforced concrete, arriving at the conclusion that "This new architecture corresponds to an art that relies on new techniques and materials. For the time being, this ideal fourth dimension involves space-related art, neon, fluorescent light, and television." During their first—and only—television appearance in May 1952, Fontana and the Spatialists in fact celebrated TV as a "long-awaited artistic medium" to which they hoped to be able to contribute their conceptions in future. It was an expectation that the mass medium was destined not to fulfill.

Apart from further collaborations with the architect Luciano Baldessari—as on the Breda pavilion at the "XXXIII Fiera di Milano" (Milan Fair, p. 26)—

Concetto spaziale, Forma, 1957
Aniline und collage on canvas, 149 x 150 cm
Milan, Fondazione Lucio Fontana

Concetto spaziale, Forma, 1957
Aniline and collage on canvas, 150 x 150 cm
Milan, Fondazione Lucio Fontana

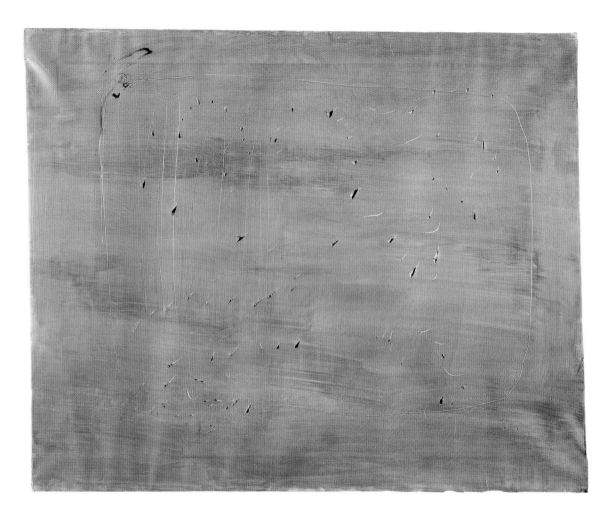

Concetto spaziale, 1959
Graffiti, perforations and aniline on paper,
mounted on canvas, 80 x 100 cm
Milan, Fondazione Lucio Fontana

Fontana began a cooperation with the interior designer Osvaldo Borsani in 1949, and in the 1950s designed furniture, lamps, and stucco ceiling decorations. In this context, Fontana did not insist on any clear demarcation between fine art and applied or decorative art. In his eyes, the term "decorative" had no negative connotations. As he once explained his "decorative" use of colors to Carla Lonzi, "Then I employed colors, really to decorative ends, in which I see nothing negative; after all, you can decorate walls, and Michelangelo decorated the Sistine Chapel. Later, 'decorating' took on this derogatory meaning. But how else can you describe it? What did Michelangelo do, paint the Sistine Chapel? He decorated it, pure and simple. At least that's how we put it in Italian." In fact, in the 1950s it was considered advanced exhibition practice, not only in Italy but internationally, to show contemporary art in conjunction with modern design, in order to illustrate their aesthetic parallels. Art historian Laszlo Glozer—with an eye to the collaboration between Fontana and Baldessari, among others—aptly characterized this phenomenon as "applied abstraction."

Much space was taken up in Fontana's oeuvre of the 1950s by several series in which the idea of the *Buchi* (pp. 30–32) was further developed

in various materials and directions. In the series of *Pietre* (stones, p. 33), begun in 1951, Fontana employed pieces of colored glass to amplify the effect of depth and the luminosity of the picture surface. The *Barocchi*, a series of the mid-1950s, reflected his continuing concern with the Baroque, an era whose preoccupation with motion in space had already been a subject of Fontana's manifestoes and terracotta sculptures of the 1930s and '40s. The tangible, relief-like impasto surfaces of the *Barocchi*—oils combined with light-reflecting materials such as sequins and glass shards—corresponded to the tendencies in gestural abstraction then predominant in Europe under such designations as "Art informel," "Tachisme," and "Art Autre." A few of the titles in the *Barocchi* series, such as *Crocifissione* (Crucifixion) and *Golgatha*, referred to Christian iconography; others—as in the numerous *Buchi*—called constellations and other stellar motifs to mind (pp. 34–35). In the series of *Gessi*, works in pastel on canvas (pp. 36–37), occasional figurative allusions occurred around 1957–58, forms recalling the silhouette of a bird or manta ray, which were described by Enrico Crispolti as "fossil butterflies"—this, too, an echo of Fontana's ceramics of the period around 1938.

Despite his uninterrupted productivity, Fontana wrote in October 1958 to Tullio d'Albisola, "At the moment I'm no good for anything. I'm waiting for solid inspiration to begin my work as a space artisan." This passage suggests both a situation of stagnation and an expectation that would apparently soon be fulfilled, and would provide the title for a further group of works. In autumn 1957, Fontana launched into a series of works on paper mounted on canvas—the *Carte* (pp. 40–41)—in which for the first time he began making multiple incisions. These were soon followed by his first slicings of monochrome canvases, a series Fontana called *Attese* (Expectations, pp. 46–53). Ugo Mulas, who photographed the artist making such incisions (p. 49)—or rather, who staged them, an already existing *Taglio* being used for some of the photographs—found a pragmatic explanation for the title *Attese*. Mulas understood it as describing the moment of hesitation and concentration before Fontana sliced the canvas with a rapid sweep of a sharp knife. A different explanation for the title was advanced by Guido Ballo in 1970. Since the water-soluble aniline paints of the first *Tagli* left cloudy textures on the canvas as they dried, Ballo explained, the *Attese* could be viewed as an allusion to the skies over Argentina, which Fontana's stepbrother Zino frequently photographed for him—a motif of nostalgia, in other words.

When Fontana began to make his *Tagli* in a more systematic way, he first primed the canvas with several coats of watery distemper, soaking it thoroughly. The incisions were made in the canvas while it was still slightly damp. As it dried, the canvas gradually contracted, causing the edges of the cut to curl—outwards or inwards, depending on whether the incision had been made from the front or the back of the painting. Finally, Fontana enlarged the aperture with his fingers and affixed black gauze behind the slit. "I am seeking to express the void," he explained in an interview with Nerio Minuzzo in 1963. "Humanity, accepting the idea of Infinity, has already accepted the idea of Nothingness."

Jan van der Marck traced the caesura in Fontana's development that led in 1958–59 to the *Tagli*, and thus a radical reduction of his style, to a kind of practical self-criticism on the artist's part. During preparations for a show

Concetto spaziale, 1959
Graffiti, perforations, incisions, ink and aniline on canvas, 79.5 x 47 cm
Rome, private collection

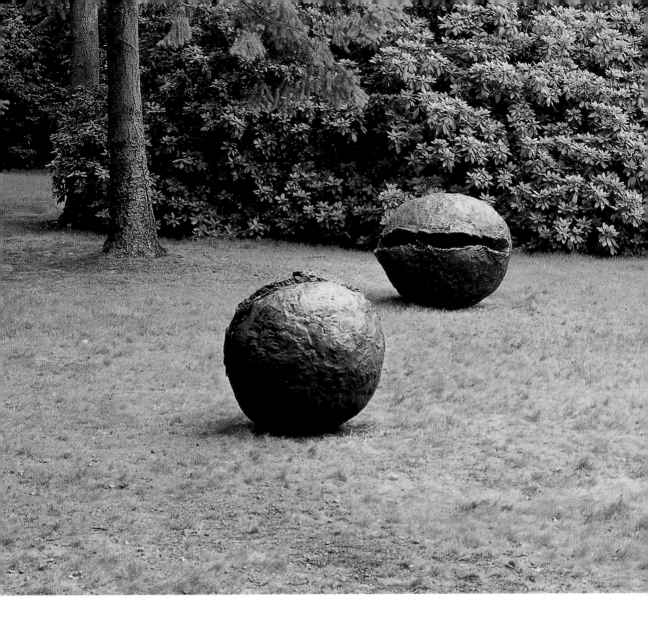

Concetto spaziale, Nature
(Spatial Concept, Natures), 1959–1960
Terracotta, diameter 92–102 cm
Berlin, Neue Nationalgalerie

at the Galerie Stadler in Paris in winter 1958–59, as van der Marck noted in 1966, Fontana angrily cut up a painting he considered unsuccessful, and accidentally discovered the potential of this gesture in the process. "Perhaps Fontana's mutilation of the canvas can be interpreted as a symbolic escape from his aesthetic predicament of being trapped in an overweighted style." This innovation of incising the canvas went hand in hand with a restriction of his palette to monochromy. A key impulse in this regard came from Fontana's encounter with Yves Klein's monochrome paintings in January 1957, at the Apollinaire Gallery in Milan. Klein's contemporary, the Milan artist Piero Manzoni, likewise caused a sensation in 1957 with his white *Achromes*, paintings employing natural stucco as a medium. In the opinion of many artists and critics—not to mention that of the art market—European

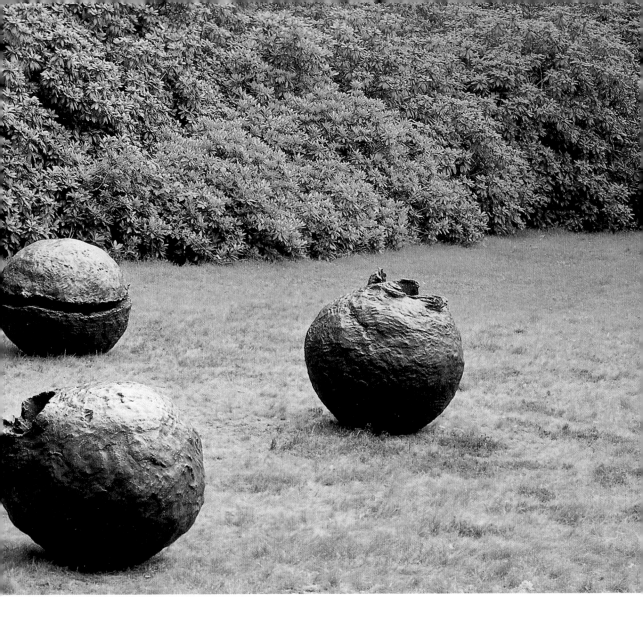

Art informel had evidently exhausted itself by the late 1950s. This circumstance was exacerbated by competition from the growing presence in European institutions of large-format paintings of American Abstract Expressionism. At the great international exhibition "Documenta 2" in Kassel, Germany, in 1959, which was viewed as an index of the situation, Fontana participated with two *Tagli*. As a result, he came to be associated in the public eye with the artists who were engaged in overcoming Art informel.

An original variation of the *Tagli* were the *Quanta*. Done in 1959–60, these were groups of several small polygonal, round or oval canvases that could be hung in varying arrangements. The title played on a theory in atomic physics. Put very simply, quanta are the smallest amounts of energy present in a wave—such as a light wave—which behave like particles.

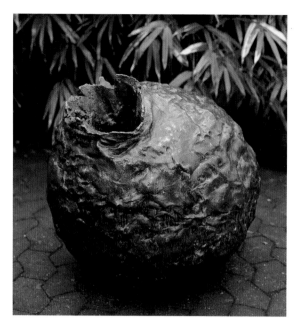
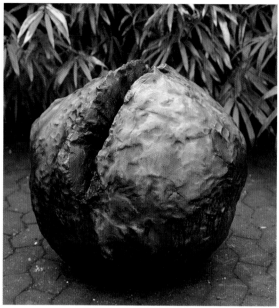

Fontana's individual canvases stand for these quantities of kinetic energy. A few polygonal, in this case hexagonal canvases, had already figured in the *Barocchi* series of the mid 1950s. In other words, Fontana began early on to experiment in a field that would come to hold a prominent position in American painting of the early 1960s, under the rubric "shaped canvases" (pp. 50–51).

In 1958–59, a large number of *Tagli* emerged. Their frequent entry into international public and private collections and the art trade—abetted by their immediate identifiability—is one of the reasons why Fontana's name continues to be associated primarily with this type of work to this day. He once frankly described his reaction to the great demand for his *Tagli* in the 1960s to Carla Lonzi: "Now I also make the incisions as a concession to the market, on which we unfortunately depend, and because the dealers and collectors are keen on them, and so I do them …" In the early 1970s, when debates over the multiplication of art works reached a culmination, the German video producer Gerry Schum described Fontana as an example of how the art system drove artists to repeat their conceptions, and as an alternative, suggested they adopt reproduction media such as film, photography and video. "The art market, that is, the communication system for art—not to say the financing system of art," stated Schum, "forced Fontana to repeat this pact of slicing the canvas over and over again. All such things, that do not necessarily contribute to focusing conceptions, result in part from market constraints, in my opinion." Fontana himself, in contrast, did not seem to believe in the idea of art editions for a broader public, telling Carla Lonzi that it tended to reflect "a lack of ideas to want to force things on the public which it does not want to accept; because art isn't popular, art is a science."

Before launching into the *Tagli*, Fontana had begun work in summer 1959 in Albisola on a series of ceramics, the *Nature*, or Natures (pp. 42–45), which

were subsequently cast in bronze. At the outset, Fontana sliced small lumps of clay like a fruit and marked the surfaces of the cut with incisions. Later, retaining the spherical shape, he began to deform it by means of holes made with a wooden stick or incisions that appeared to reach deep into the interior of the sphere. The *Nature* triggered a whole series of mental associations. Giovanni Lista was reminded of "asteroids that had fallen to earth." To the art historian Günter Aust, their "natural form resembles huge fruits, yet with their deep incisions and protruding crater edges, they seem like a simile for tellurian processes." In his interview with Carla Lonzi, Fontana explained that he was thinking of moon craters when executing the spheres, and imagining that man was breaking "into this oppressive atmosphere and leaving a sign of his arrival behind … That is what I wanted to express with these immobile forms, a sign that would awaken inert matter to life."

The penetration of the terracotta spheres with a wooden stick in the *Nature* series had obvious phallic connotations, which Fontana apparently underscored by having himself photographed at work on the pieces (p. 45). A similar motif appeared as early as 1946 in a drawing. The association with body apertures is underscored by the series' title. In Italian, "Natura," the singular of "Nature," is a colloquial term for the genitals, especially the female genitals.

Even more clearly than the *Buchi*, the *Tagli* suggest gaping wounds or vaginas—a motif Fontana occasionally emphasized by means of colored markings. Numerous commentators have interpreted the perforations and incisions along these lines. Sarah Whitfield was reminded by the *Buchi* of the bullet wound in his arm Fontana had suffered in World War I. Moreover, she

Benjamin H. D. Buchloh: "Do you remember what especially interested you about Fontana and Pollock?"
Gerhard Richter: "Their impudence! I was very intrigued and very affected by it. I might even say that these pictures were the real reason for my leaving East Germany. I realized there was something wrong about my way of thinking."
BENJAMIN H. D. BUCHLOH AND GERHARD RICHTER, 1986

Lucio Fontana working on the *Nature* sculptures, 1960

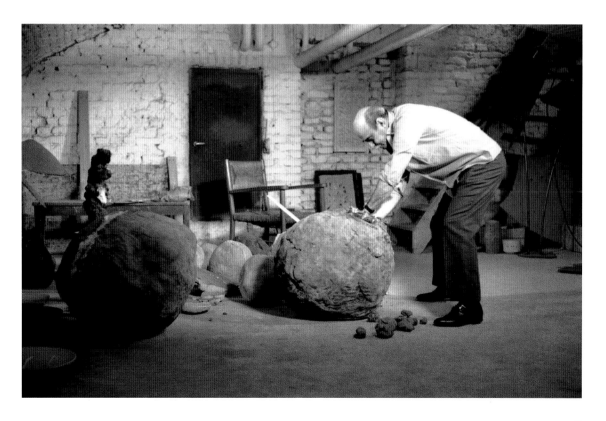

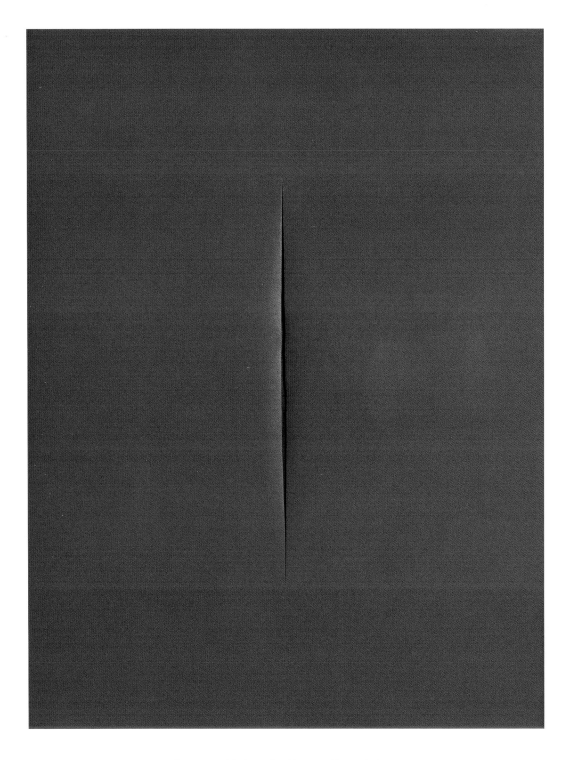

Concetto spaziale, Attesa (Spatial Concept, Expectation), 1967
Watercolor on canvas and lacquered wooden frame, 180.5 x 140 cm
Zurich, Kunsthaus Zürich

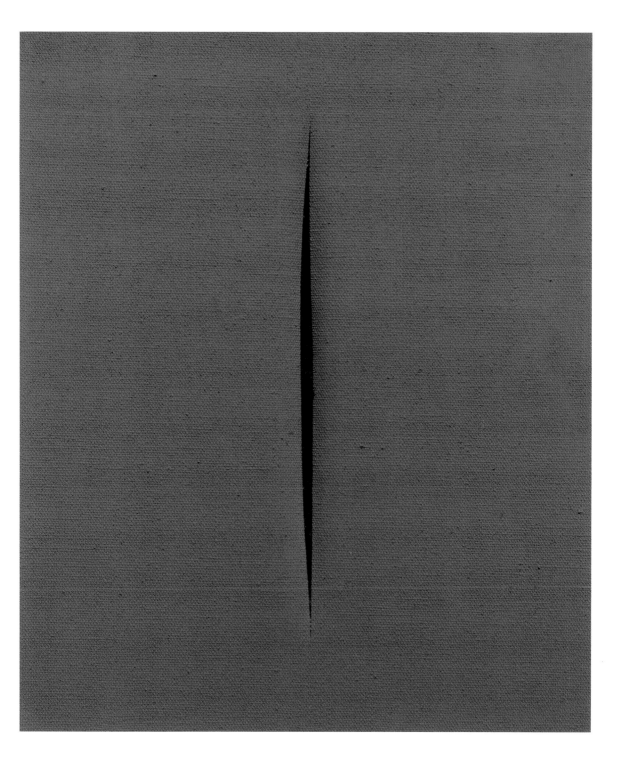

Concetto spaziale, Attesa, 1966
Watercolor on canvas, 46 x 38 cm
Rome, private collection

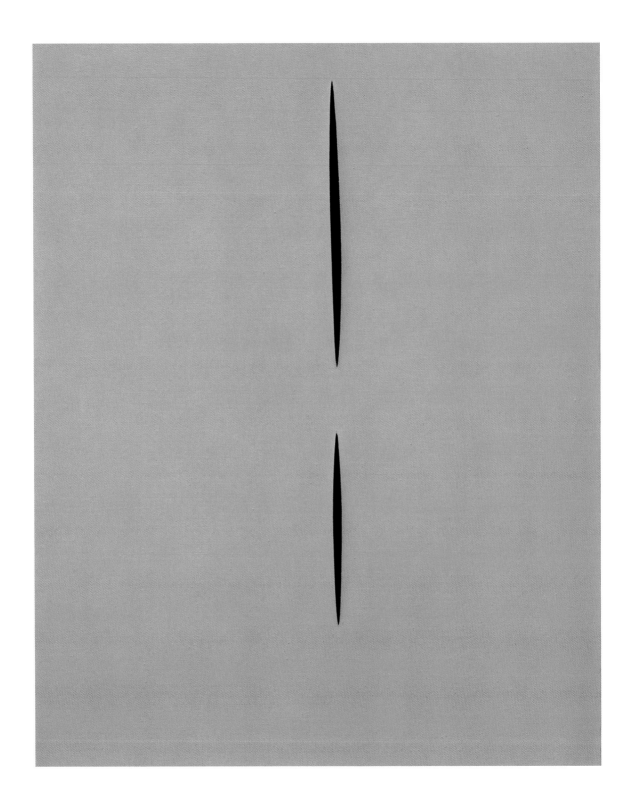

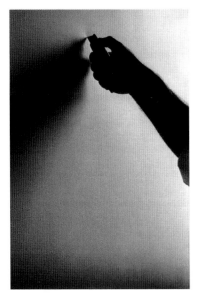

Lucio Fontana executing an incision, 1964

found an early corroboration for reading the *Tagli* as wounds in a bronze statue of Christ, designed by Fontana in 1935 for the tomb of the Castellotti family in Milan, whose open hands bore incision-like stigma. Birgit Pelzer described the *Buchi* and *Tagli* in a more general sense, as visual metaphors for the unconscious mind. As the *Manifiesto Blanco* declared, "every artistic conception springs from the unconscious, that magnificent storehouse of all perceived images." In Pelzer's view, Fontana's "field of experimentation … [focused on] an excluded, inaccessible center that is protected by barriers, a region so intimate that it consists only of externals. By employing the hole as a structuring means of expression, Fontana attempted to demarcate the unutterable with his activity. Because what cannot be said, can be done, seen, heard, and felt." Pelzer, adopting a term from the French psychoanalyst Jacques Lacan, called this "excluded, inaccessible center"—the unconscious mind—the *extime,* "the location where the internal is outside and the external is inside, the *extimity* that designates a cleaving apart."

The art historian Yve-Alain Bois likewise approached Fontana's art—not only the *Buchi* and *Tagli* but the less appreciated "early work" prior to 1947—with the aid of psychoanalytic categories. It was obvious to the point of cliché, stated Bois, that Fontana's most famous works, the perforations and incisions, were sadistic in nature. Fontana's work shortly before the emergence of the first *Buchi* in fact included a drawing that plays on another "cliché," that of Latin American machismo. In this self-portrait of 1947, the author proclaims, in a speech bubble, "Yo soy el terror delle femmes!" (I am the terror of women! p. 23). Bois, based on considerations of the French philosopher Georges Bataille, sees Fontana's work as a regression to the formless and the conceptless. He describes this as a contradictory double movement between idea, concept and amorphousness, endlessness: "Again, one has recourse to the notion of the sublimation of matter, a sublimation which was, however, denied by the obscenity of the polychrome scatology, by the radical materiology, by the perforating act. The slit paintings represent precisely this contradictory double movement—the sign of an inevitable failure. It is wrong to consider them Fontana's best works, but they are his most exemplary achievement."

ILLUSTRATION PAGE 48:
Concetto spaziale, Attese
(Spatial Concept, Expectations), 1959
Watercolor on canvas, 125 x 100 cm
Paris, Centre Georges Pompidou,
Musée National d'Art Moderne

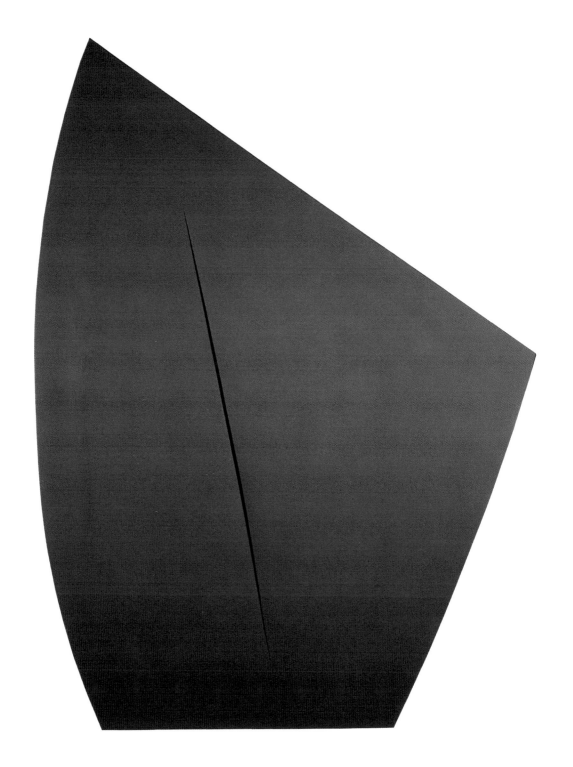

Concetto spaziale, Attesa, 1959
Watercolor on canvas, 118 x 88 cm
Isola del Liri, private collection

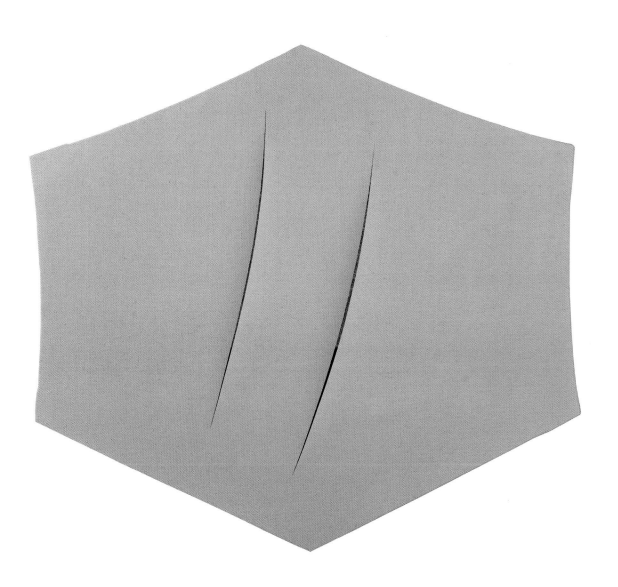

Concetto spaziale, Attese, 1959
Watercolor on canvas, 66 x 73.5 cm
Kiel, Kunsthalle Kiel

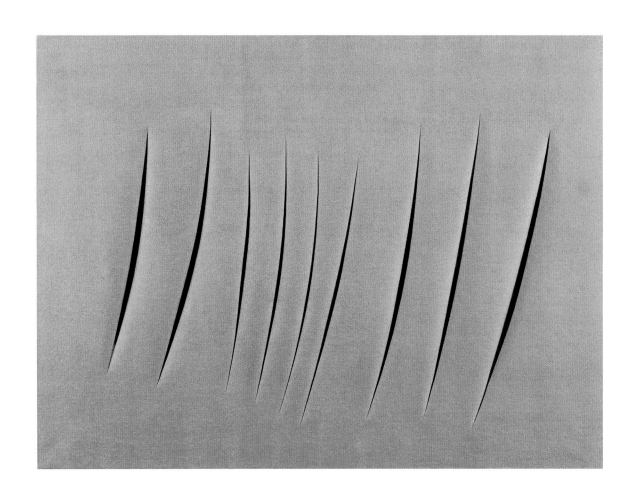

Concetto spaziale, Attese, 1962
Oil on canvas, 97 x 130 cm
Stockholm, Ressle Gallery

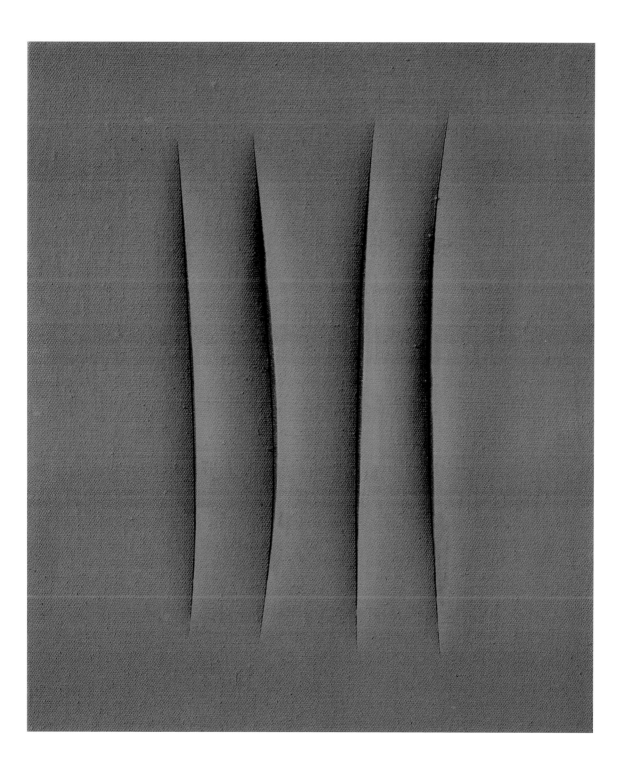

Concetto spaziale, Attese, 1961
Watercolor on canvas, 55.5 x 46.5 cm
Rome, private collection

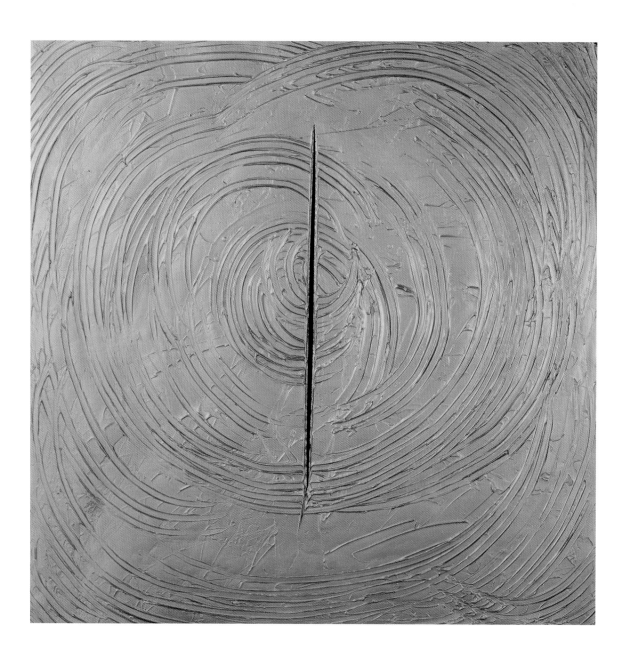

"The reincarnation of a doge"—
Between Venice and New York

The 1960s were a decade of great productivity for Fontana, in which he contin-
ued his *Buchi* and *Tagli* in a range of new formats and employing new materials.
In addition, in a series of room installations he recurred to his pioneering work
of 1949, *Ambiente spaziale a luce nera* (p. 27). Even though interviews from the
period show him taking a defensive stance and vociferously insisting on the
originality of his ideas, Fontana's leading position in Italian art in the early 1960s
was apparently already uncontested by that point in time. In June 1962, the
Italian weekly *Domenica del Corriere* conducted a survey under the title "Chi
sono i nostri pittori più importanti?" (Who are our most important painters?)
21 Italian and international critics and art experts were queried. Apart from vot-
ing for the Italian painter they considered most significant, the participants were
asked to name the artists whose works they would most like to own themselves.
Fontana garnered the highest number of mentions on both queries. Moreover,
no one in the all-male group of experts evidently had any difficulty in classifying
Fontana as a "painter"—in spite of his declaration that the *Buchi* represented a
"new fact in sculpture."

Some months prior to the *Domenica del Corriere* survey, Fontana's first
one-man show in the U.S. had taken place. In November 1961, the Martha
Jackson Gallery in New York showed his "Ten Paintings of Venice." These
were part of a series devoted to the city, which had been done earlier that
year for a group exhibition, "Arte e contemplazione" (Art and Contempla-
tion), at the Palazzo Grassi in Venice (pp. 54, 58–59). The titles of the paint-
ings, unusually narrative in character by Fontana's standards—such as
Wedding in Venice, *Night of Love in Venice*, and *Venice was All Gold/The
Baroque of Venice*—evoked the surprisingly conventional idea of Venice
as a favorite destination for art lovers and honeymooners. In this series of
Buchi and *Tagli*, Fontana largely employed metallic silver or gold paint
applied in thick impasto. Occasionally he built up the surface to produce
relief, plastic effects recalling stucco ornament, and heightened the effect
still further by inserting pieces of colored glass. The choice of these sumptu-
ous materials was reminiscent of both Murano glass objects and the gilded
mosaics of San Marco—a traditional technique Fontana had already revived
in the late 1930s, in the portrait bust of his wife Teresita (p. 12). The New
York show was accompanied by a catalogue in which a two-page spread was

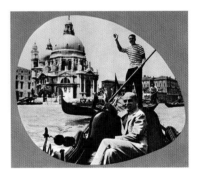

Lucio Fontana in a gondola in Venice, 1966

ILLUSTRATION PAGE 54:
Concetto spaziale, Venezia era tutta d'oro
(Spatial Concept, Venice was All Gold/
The Baroque of Venice), 1961
Oil and incision on canvas, 150 x 150 cm
Madrid, Fundación Colección Thyssen-
Bornemisza

devoted to a black-and-white photograph that in this context seemed rather incongruous, since it might have come straight from a private album (p. 55). Oval in shape and surrounded by a gold mat, the picture showed Fontana in a gondola on the Canal Grande, he and the gondoliere waving at the viewer and smiling broadly into the camera, like a tourist. To top things off, the church of Santa Maria della Salute, an icon of Venetian Baroque architecture, was visible in the background. This obviously carefully staged photograph left it up the viewer to interpret it as a humorous exaggeration or an ironic stab at the Venice clichés it contained. Yet there was at least one acute observer, Jan van der Marck, who detected a strong affinity with the city on Fontana's part. Writing in 1974, the art historian noted, "The city's regal splendor fitted him like a glove. The reincarnation of a doge, the president of a Latin republic, or the head of an international cartel? This was the image he projected."

There could probably not have been a better point in time to introduce Fontana to American audiences. The Abstract Expressionism of the New York School, the predominant tendency in painting in the late 1940s and 1950s, had already passed its zenith. The widely adopted formalistic definition of art, according to which each medium should limit itself to an investigation of its own intrinsic conditions and not overstep the borderline to other media, was being increasingly contested by a younger generation of artists and critics. In New York, a transition was announced by the first public appearances and shows of artists like Jasper Johns and Robert Rauschenberg, Andy Warhol and Roy Lichtenstein, Marisol Escobar, George Segal, Simone Forti, Yayoi Kusama, Allen Kaprow, and Yoko Ono. The international success of Pop Art could no longer be ignored, and the emergence of new and innovative forms of art such as Happenings and Fluxus was attracting widespread attention. In this climate of change, the English critic and curator Lawrence Alloway was invited to provide an article for the catalogue of Fontana's "Ten Paintings of Venice." Back in 1956, Alloway had written a new chapter in art history when he curated "This is Tomorrow," a London exhibition that addressed the phenomena of mass culture and proclaimed the coming of Pop. In his subsequent writings, too, Alloway continued to deny that any strict distinction could be made between avant-garde art and popular culture. In 1961 the critic had left London for a post as senior curator at the Guggenheim Museum in New York. Alloway's perception of the oscillation between high art and popular culture virtually predestined him to explain the nature of Fontana's Venice paintings to an American audience. In his essay Alloway described Fontana as a "Man on the Border," and stated, "It is clear that Fontana is antagonistic to those traditions in modern art which commit artists to the possession of a single medium. When he declares that 'the painted surface, the erected stone, no longer have a meaning,' he is not writing in homage to plastics, but declaring a kind of border warfare. He is the enemy of media purity, and chooses the ambiguous border between the arts, where paintings look like sculpture and sculpture meets painting halfway, in a series of overlappings and conflations." Another borderline case in Fontana's art, said Alloway, was that between fine and applied art, as indicated by his addition of glass stones to the canvas: "It is part of his border activity that his works often have a connection with the chic. …What happens is that the chic is itself made lyrical and problematic; in the same spirit Mallarmé wrote in a fashion magazine."

ILLUSTRATION PAGE 57:
Concetto spaziale, Ritratto di Iris Clert
(Spatial Concept, Portrait of Iris Clert), 1961
Oil, graffiti, incision and pieces of glass on canvas, 92 x 73 cm
Milan, private collection

In 1961, Fontana had his first show with Iris Clert. Clert had opened her gallery in Paris in 1956, and caused a furore with her exhibitions of Yves Klein, Arman, Jean Tinguely and Ad Reinhardt. In his *Portrait of Iris Clert*, Fontana's use of gold paint—recalling Byzantine icons—may allude to Clert's Greek background, and the vertical incision at the height of the face might be read as a provocative "iconoclastic" gesture.

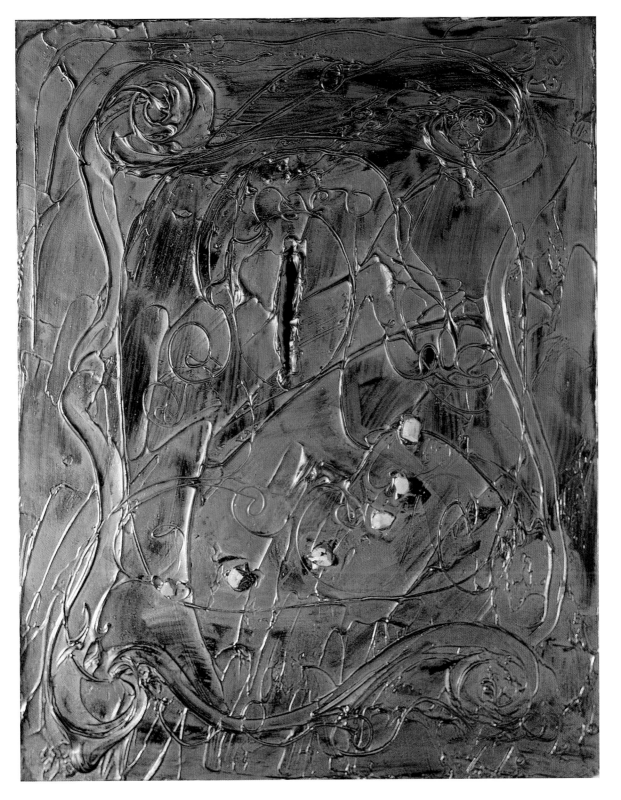

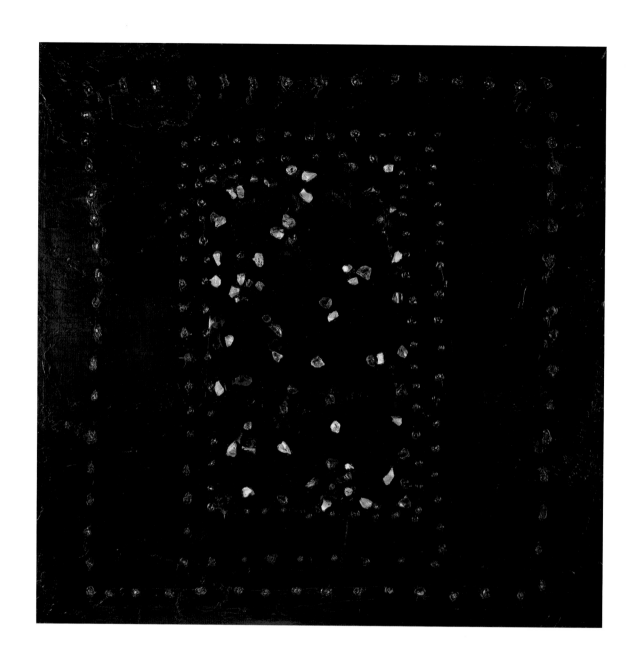

Concetto spaziale, In piazza San Marco di notte con Teresita
(Spatial Concept, On the Piazza San Marco with Teresita at Night), 1961
Oil, perforations and pieces of glass on canvas, 150 x 150 cm
Milan, private collection

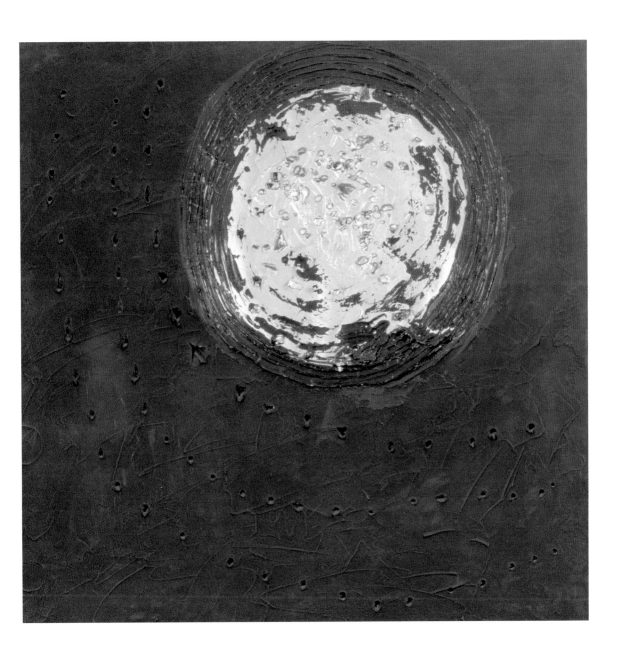

Concetto spaziale, Luna a Venezia (Spatial Concept, Moon in Venice), 1961
Oil, perforations and pieces of glass on canvas, 150 x 150 cm
Milan, private collection

Concetto spaziale, 1960
Oil on canvas, 110 x 250 cm
Cologne, private collection

Nude, 1964–1965
Oil and gouache on paper, 50 x 23.6 cm
Milan, Fondazione Lucio Fontana

ILLUSTRATION PAGE 63:
Concetto spaziale, 1962
Oil, incision and graffiti on canvas, 100 x 81 cm
Florence, private collection

This comparison with the French poet Stéphane Mallarmé (1842–98), one of the most significant representatives of Symbolism and pioneer of modern poetry, doubtless amounted to a nobilitation of the "Paintings of Venice." Still, the reactions of both American and British critics to Fontana's art remained non-existent to negative up to the 1980s, as Yve-Alain Bois pointed out in 1987 in connection with an extensive Fontana retrospective at the Centre Pompidou in Paris. The British critic Norbert Lynton, for instance, stated in 1963 that Fontana's "vast range of works [are] linked by an all-pervading aroma of aristocratic taste and preciousness. This makes him unmanageable for Anglo-Saxon stomachs, but that is their loss, not his." The critic Sidney Tillim, writing in the American journal *Arts Magazine* in 1962, viewed Fontana's practice of destroying the painting support while reveling in luminous colors and ornamentation as a contradiction, calling him a "successful decorator" whose metallic, glittering oils and colored Murano glass were intended to draw attention away from the proclivity for destruction evident in his slicings of the canvas. The critic Paul Oliver even felt reminded of "scattered decorations on a cake icing" in view of Fontana's bits of glass. In the eyes of art historian Anthony White, Fontana apparently used such decorative elements to parody an aesthetic widespread in Italy, a penchant for tooled gold and marble that indulged in the aristocratic tastes of past eras. In sum, the "Paintings of Venice" touched off a lasting controversy that was indicative of their ambivalent and provocative character.

Despite the skepticism with which many art critics reacted to Fontana's works, the New York show of the "Paintings of Venice" was a success with collectors. "Ten paintings already sold before the vernissage!" Fontana enthused in a letter of 19 November 1961. In the course of his stay in America he had an opportunity to see his works in further, important collections. One of these was the collection of the Kaufmann family, housed in their legendary vacation residence in Pennsylvania, "Fallingwater," designed in 1939 by Frank Lloyd Wright. In addition, Fontana was overwhelmed by New York skyscraper architecture. His enthusiasm was so great that on his return to Italy he took it as the point of departure for a new series of works. "New Yorck [sic] is more beautiful than Venice! The glass skyscrapers look like huge waterfalls cascading from the sky! At night the city is a great chain of rubies,

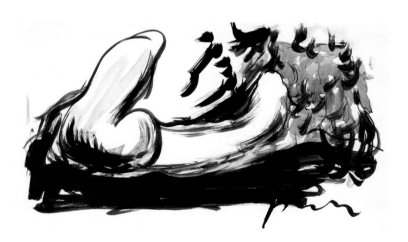

Reclining Nude, 1964–1965
Ink on paper, 70 x 100 cm
Milan, Fondazione Lucio Fontana

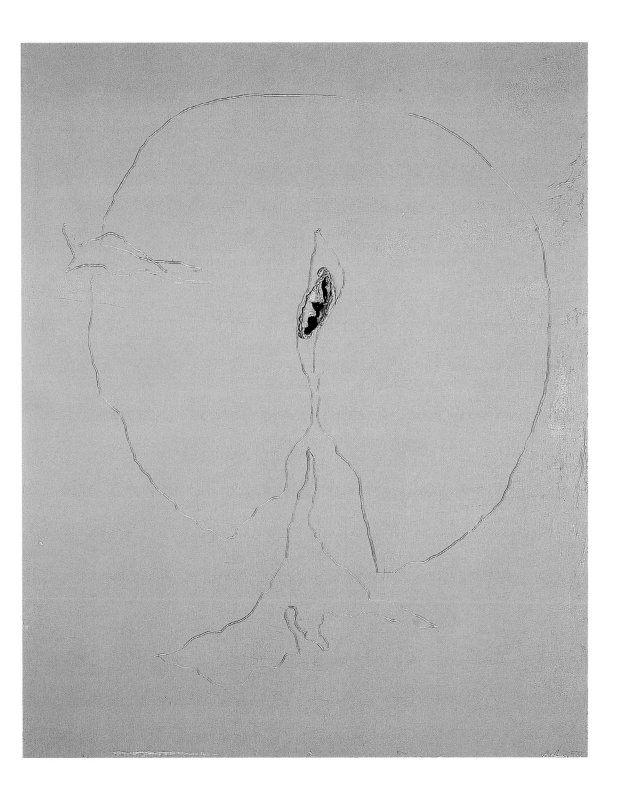

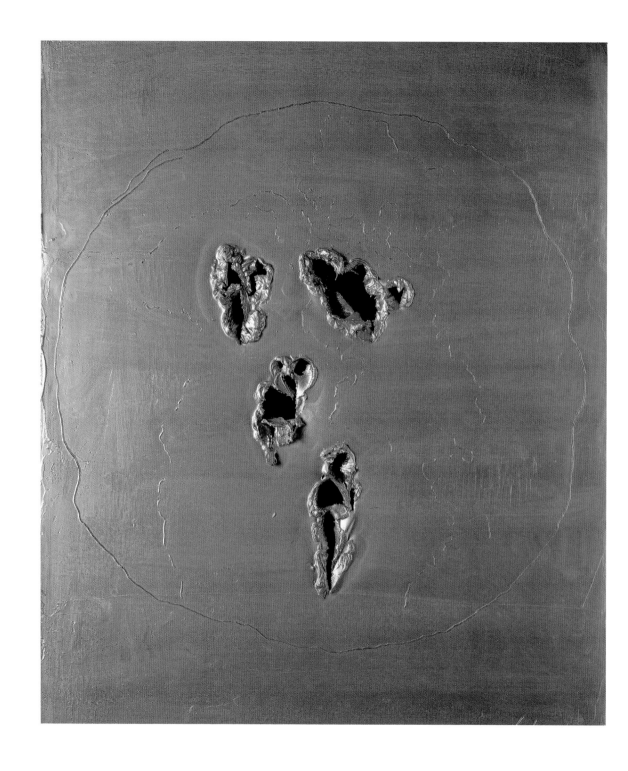

Concetto spaziale, 1964
Oil, rips and graffiti on canvas, 73 x 60 cm
Private collection

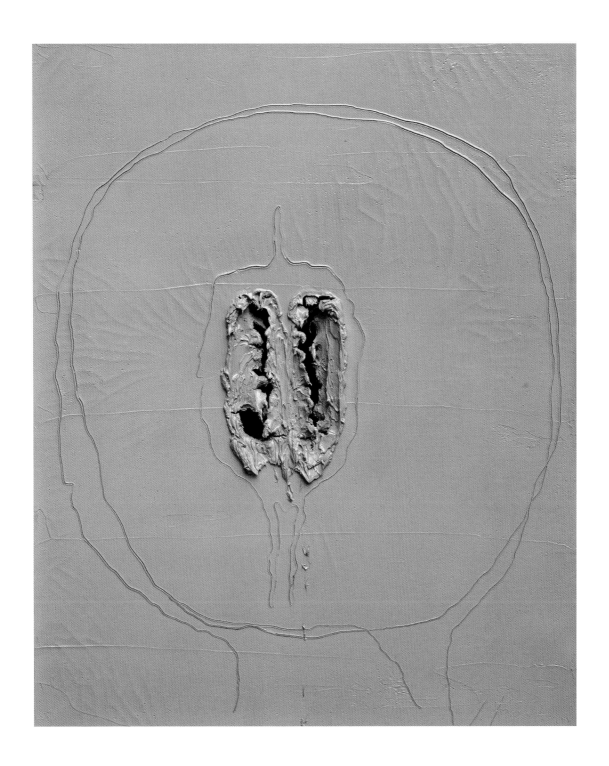

Concetto spaziale, 1968
Oil, rips and graffiti on canvas, 81 x 65 cm
Milan, private collection

sapphires and emeralds," he wrote in a postcard of 24 November 1961. Before the year was out, this enthusiasm resulted in a counterpoint to the "Paintings of Venice," a new series entitled *Metalli* (Metals, pp. 66–67). To capture the impression of sunlight glancing off the glass and steel architecture, Fontana employed sheets of copper, brass or aluminum into which he punched holes and made vertical incisions, and whose surface he enlivened with corrugated or engraved patterns.

In this and other new series of the 1960s—the *Fine di Dio* (1963–64, pp. 72–73), *Teatrini* (1964–66, pp. 74, 84–89, 91), and *Ellissi* (1967, p. 71)— Fontana paid tribute to a change that affected large parts of artistic production during that decade. This was the tendency to standardization and the use of industrial materials and manufacturing methods, an approach that played an especially important role in Pop and Minimal Art. In the *Fine di Dio* (End of God) series, for instance, Fontana employed canvases on egg-shaped stretchers with a uniform height of 1.78 meters, intended to correspond with the viewer's height. The surface of these monochrome works was covered with heavily applied oil, usually in intense, bright candy colors like yellow, orange, green, or pink, and exhibited more or less numerous organic-looking perforations. Sometimes the pattern of holes was surrounded by incised marks, or the surface lent additional brilliance by means of sequins. The title *Fine di Dio* referred to Friedrich Nietzsche's The Gay Science, 1882, in which a demented man stands on a marketplace and proclaims the "death of God." There would seem to be a certain tension between Fontana's title, which can be read as an atheistic manifesto, and the organic, egg-shape of

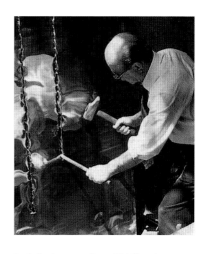

Lucio Fontana executing a *Metallo*, 1961

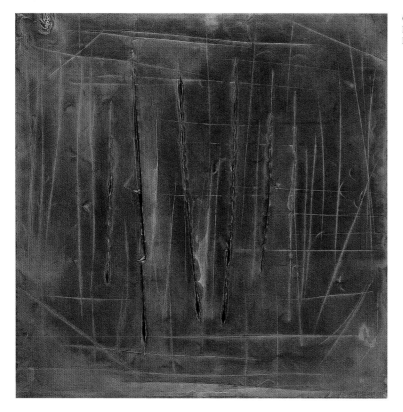

Concetto spaziale, New York 8, 1962
Brass with incisions and graffiti, 63 x 63 cm
Brussels, private collection

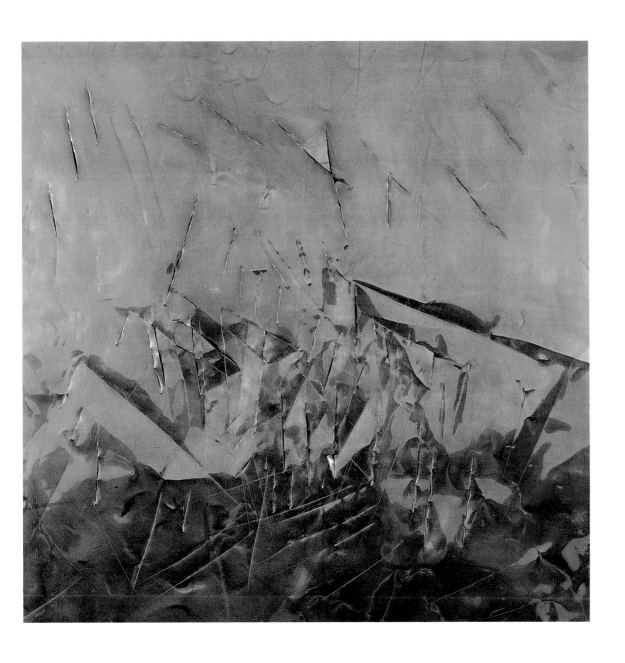

Concetto spaziale, New York 9, 1962
Copper with incisions and graffiti, 64 x 65 cm
Cassano d'Adda, private collection

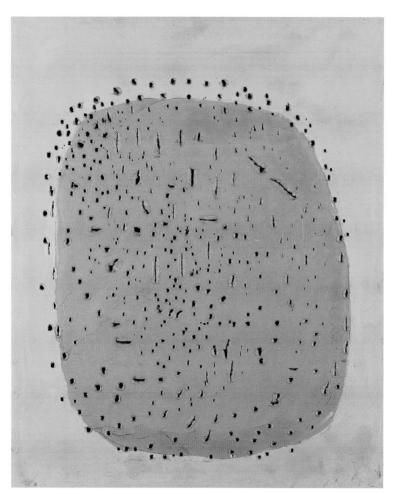

Concetto spaziale, 1960
Oil on canvas, 100.5 x 81.5 cm
New York, Marisa del Re Gallery

In the early 1960s, Fontana began to employ oil
paints. Regarding the relationship between the
frequently circular marks incised in the paint
layer and the perforations in the canvas, he
explained in 1962 that the drawing stood for
"the path of man in space, his dismay and hor-
ror of going astray," and the incisions for "the
subsequent gesture of an anxiety that had
grown unbearable."

ILLUSTRATION PAGE 69 BOTTOM:
Concetto spaziale, Trinità
(Spatial Concept, Trinity), 1966
Three-part work: Watercolor on canvas and
lacquered wooden frame, 203 x 203 cm each
Milan, Fondazione Marconi

the pictures, which is symbolic of life and—in Christian tradition—of the
Resurrection. A contradiction that Fontana explained as follows in his 1967
conversation with Carla Lonzi: "God is invisible, God is incomprehensible;
this is why no artist today can depict God seated on a throne with the world
in his hands and a beard . . . The religions, too, must adapt themselves to the
state of science . . ." Fontana understood the *Fine di Dio* series, in the context
of contemporary ecclesiastical art, not least as a polemic against the practice
of the Italian Catholic Church of continuing to order portraits of cardinals
and saints from figurative artists. In addition, Fontana underscored a change
in his own stance with this series. In the early 1950s Fontana had himself
conceived an elaborate figurative design for the fifth door of Milan Cathedral
(p. 93), and until the middle of that decade, especially in commissioned
works, he continued to supply objective interpretations of religious motifs.
A later work like *Trinità* (Trinity, p. 69 bottom), in contrast, a constellation
of three square white *Buchi* in a white lacquered wooden frame, reflected
Fontana's effort to translate a traditional Christian motif into non-figurative
visual terms.

"I did not make holes in order to wreck the pic-
ture. On the contrary, I made holes in order to
find something else …"
LUCIO FONTANA, 1968

The involvement with organic forms evident in the egg-shape of the *Fine di Dio* canvases became even more obvious in the *Olii* (pp. 63–65, 68), a series whose beginning dated back to the late 1950s. These were oil paintings on canvas, whose surface was opened with perforations or incisions. Beginning about 1962, the paint application grew increasingly thick and tangible. The *Buchi* took the form of deep, wide craters, recalling injuries or gaping body apertures. A few of the *Olii*, which had only a single, central hole, were subtitled *Ombelichi* (Navels), amplifying associations with corporeality. "Naturally oil paint is a material for Fontana," remarked Enrico Crispolti, "and he always employs it as such, as a ductile material that permits inscriptions and retains the mark of the gesture of scratching into it or perforating and lacerating it." The majority of the *Olii* were monochrome, frequently white or pink, "a delicate, almost flesh-colored pink," as Crispolti noted. This brings to mind the famous statement, "Flesh was the reason oil painting was invented," made by the American painter Willem de Kooning back in 1950, and Fontana's handling of oils in this series of works seems to corroborate this declaration. In fact, during that period Fontana was in the habit of devoting his Sundays to drawing from a nude model—drawings that were not publicly exhibited to any extent until the late 1980s. It is certainly tempting to conclude that this activity may well have influenced the physical presence of the *Olii* (p. 62).

A counterpoint to the organic, "vulnerable" surfaces of the *Olii* was formed by the *Ellissi* (Ellipses, p. 71), oval wooden panels of uniform format painted in colored lacquer and covered with regular patterns of small holes. The group of 30 *Ellissi* had the appearance of something mechanically produced in series, corresponding in this respect with concurrent tendencies in Pop and Minimal Art. On the occasion of a show of the *Ellissi* at the Marlborough Gallery in Rome, the critic Leonardo Sinisgalli remarked, "The twelve or thirteen panels on view in the Marlborough Gallery are all the same.… Indeed Fontana's gesture … is a parody of mastery, efficiency, plodding patience." In addition to the *Ellissi*, the year 1967 saw the emergence of a few sculptures in lacquered metal, whose flawless surface recalled factory-new automobile chassis. These pieces belonged to the category of *Tagli* or *Buchi*, some mounted on easel-like tripods, and egg- or cigar-shaped objects

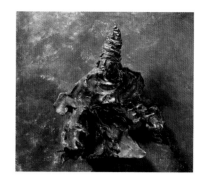

ILLUSTRATION TOP:
Papa Martino V (Pope Martin V), 1950–1951
Bronze, 95 x 81 cm
Rome, Musei del Vaticano, Pinacoteca

ILLUSTRATION ABOVE:
Lucio Fontana executing a sculpture of the pope for the fifth door of Milan Cathedral, 1951

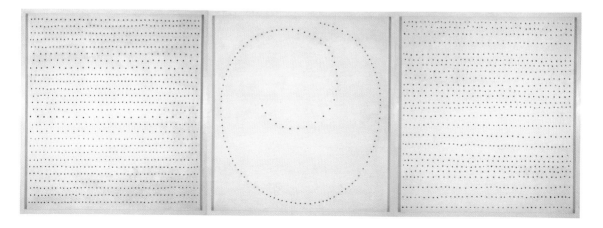

reminiscent of missiles or space capsules (p. 70 top). In fact, Fontana avidly kept up to date on the latest advances in space travel, which were to culminate in 1969 in the first American moon landing. This curiosity about scientific and technological developments to come can be traced all the way back to the *Manifiesto Blanco* of 1946, which included the following statement: "The discovery of new physical forces, the conquering of matter and outer space, are gradually imposing living conditions on mankind that have never before existed in the course of history."

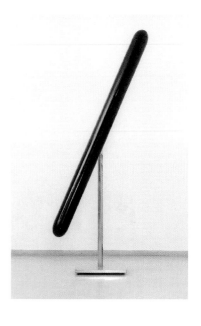

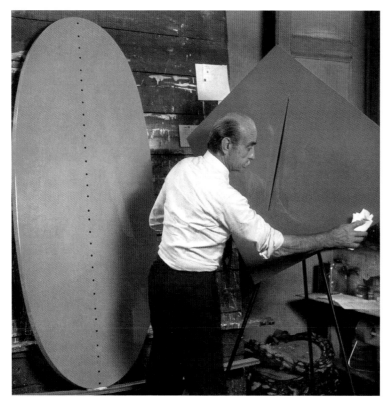

ILLUSTRATION ABOVE:
Concetto spaziale, 1967
Black lacquered metal with perforations on integrated mount, 200 x 14 x 14 cm
Milan, Fondazione Lucio Fontana

ILLUSTRATION LEFT:
Lucio Fontana at work, 1967

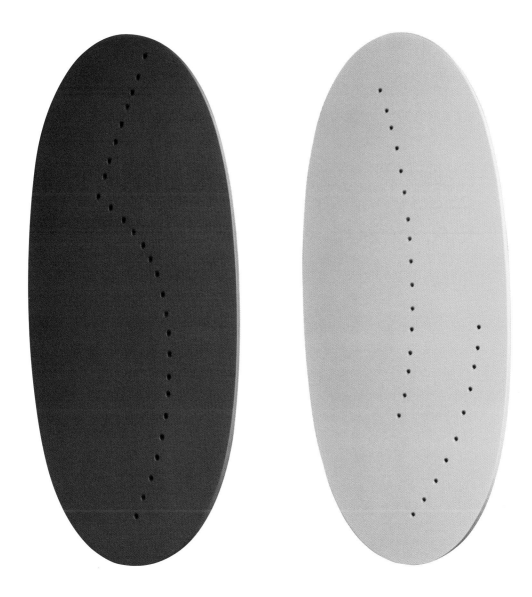

Concetto spaziale, Ellisse (Spatial Concept, Ellipse), 1967
Lacquered wood, 173 x 72 cm
Rome, private collection

Concetto spaziale, Ellisse, 1967
Lacquered wood, 173 x 72 cm
Brussels, Galerie Françoise Mayer

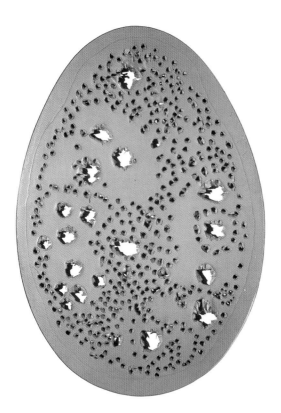

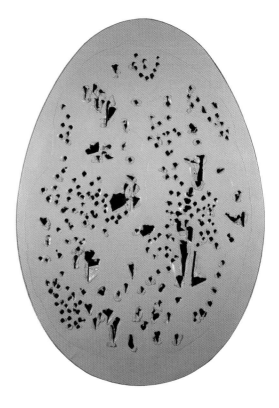

Concetto spaziale, La Fine di Dio
(Spatial Concept, The End of God), 1963
Oil, incisions, perforations and graffiti on canvas, 178 x 123 cm
Germany, private collection

Concetto spaziale, La Fine di Dio, 1963
Oil, incisions, perforations and graffiti on canvas, 178 x 123 cm
Milan, private collection

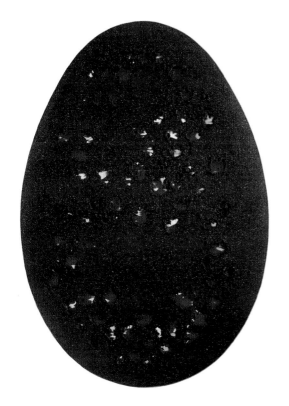

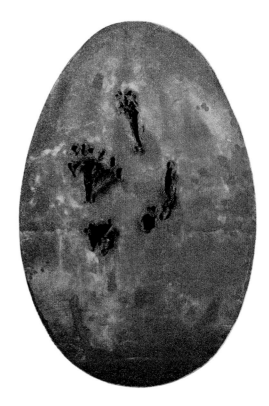

Concetto spaziale, La Fine di Dio, 1963
Oil, incisions, perforations, sequins und graffiti on canvas, 178 x 123 cm
Milan, private collection

Concetto spaziale, La Fine di Dio, 1963–1964
Oil, incisions, and sequins on canvas, 178 x 123 cm
Florence, private collection

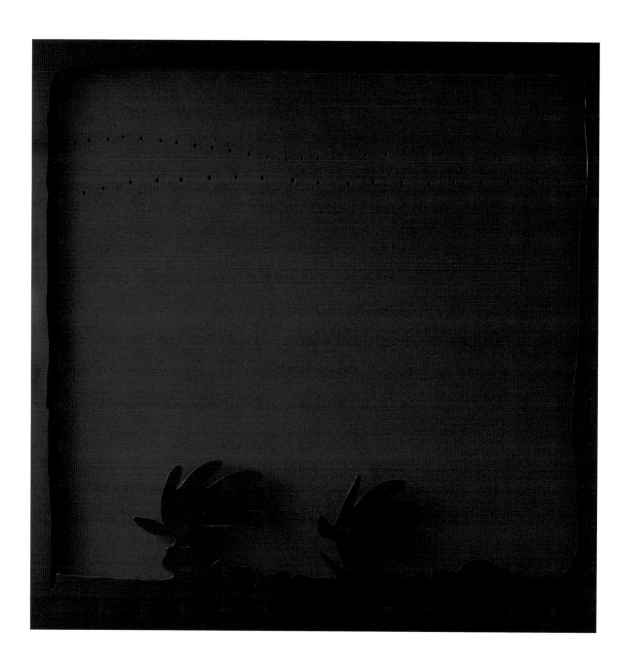

"Open the doors!"—*Teatrini* and *Ambienti*

The first years of the 1960s saw Fontana renewing and increasing his involvement with the space-occupying approach of the *Ambiente spaziale*, which had been introduced in 1949 by *Ambiente spaziale a luce nera* (p. 27) at the Galleria del Naviglio in Milan. For the exhibition "Dalla natura all'arte" (From Nature to Art) at Palazzo Grassi in 1960, he turned to the *Natures* series of spherical terracotta sculptures to develop an installation titled *Esaltazione di una forma* (Exaltation of a Form, p. 76). In a first dimly-lighted room with ocher-colored walls, a number of these *Natures* were mounted on rough wooden crates. One wall bore the word "MADRE" (mother) in large capitals, and "FONTANA" appeared at the entrance. The second room, devoted to an *Exaltation of a Form*, resembled an inaccessible cave, "a grotto decorated with gathered red satin with transparent, diagonal bands of stretched textiles of skin-like sensuality," reported Paul Davay in the journal *Les Beaux-Arts*. In the middle of this web rose an inclined cube, illuminated from within. Its reddish light amplified the organic, corporeal effect of the *Ambience*. In *Exaltation of a Form*, Fontana referred back to a work by Kurt Schwitters, the *Merzbau*, which was familiar to people in Milan at that period from exhibitions and publications. Begun in 1923 in Hanover, Schwitters's *Merzbau* was an intricately-structured interior, a work in progress destined never to be finished, on which the artist worked for decades. In the middle of this *Gesamtkunstwerk*—much as in Fontana's installation—stood a free-standing sculpture, called the *Cathedral of Erotic Misery*. Moreover, Fontana's space criss-crossed with lengths of cloth recalled Marcel Duchamp's renowned web of string, *One Mile of String*, created for the New York presentation of the "First Papers of Surrealism" in 1942, an installation that well-nigh prevented visitors from entering the exhibition at all.

Fontana continued the principle of space-related installations—albeit in a cool, technical idiom that was a far cry from the Palazzo Grassi *Ambiente spaziale*—in his *Fonti di energia* (Sources of Energy, p. 79). For the Turin exhibition "Italia 61. Moda, Stile, Costumi" (Italy 61: Fashion, Style, Customs), Fontana collaborated with the architects Gian Emilio, Piero and Anna Monti on the design of a ceiling piece consisting of numerous straight, criss-crossing neon tubes in shades of green and blue that formed an approximately 7-meter-high glowing configuration under the ceiling of the room. As one of the architects involved later recalled, Fontana developed this piece under

Lucio Fontana in front of a *Teatrino*, 1965

ILLUSTRATION PAGE 74:
Concetto spaziale, Teatrino
(Spatial Concept, Little Theater), 1965
Watercolor on canvas and lacquered wooden frame, 130 x 130 cm
Milan, private collection

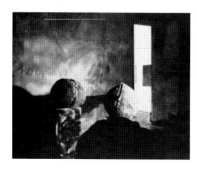

Esaltazione di una forma
(Exaltation of a Form), 1960
Exhibition "Dalla natura all'arte,"
Palazzo Grassi, Venice
Above: Installation view
Below: Various materials
destroyed

ILLUSTRATION PAGE 77:
Cubo di luce (struttura luminosa)
(Cube of Light, Luminous Structure), 1959–1960
80 fluorescent tubes on metal structure,
160 x 160 x 160 cm
Munich, Städtische Galerie im Lenbachhaus

the impression of the beginning of manned space flight that year. In the course of the 1960s, neon and fluorescent lighting were discovered as media by a number of artists, including Dan Flavin, Joseph Kosuth and Bruce Nauman, and, in Italy, by Gianni Colombo, Mario Merz and Mauricio Nannucci.

In retrospect, Fontana thought his early employment of ultraviolet and neon light had been insufficiently appreciated by the critics of the day. One reason why he largely discontinued work in this mode after 1949, he said in 1967, was the negative echo and lack of public interest: "I did not continue to focus on it, because I had no means, no neon light. I did two or three neon sculptures and then ran out of money, and had to leave it at that. Nowadays any young artist can work with neon, with light sculptures—the time is ripe for it." Fontana's *Neon* of 1966 (p. 78 bottom) was a statement evidently addressed to these "young artists." This work consisted of two 1.2-meter-long fluorescent tubes mounted in a corner under the ceiling in Fontana's residence. The rigorous geometry of the piece, unusual for Fontana, recalls the fluorescent works of the American Dan Flavin, whose installations of commercially-available fluorescent lights caused a furore when first shown in 1963 (p. 78 top).

In the 1960s, such experiments with traditionally non-artistic, mundane materials and the art form of installations, increasingly challenged the conventional media of painting and sculpture. This may have been one reason for Fontana's concentration on *Ambienti spaziali* at that period. In addition, such *Spatial Ambiences* could function as settings for his paintings. For the XXXIII Venice Biennale in 1966, Fontana collaborated with the architect

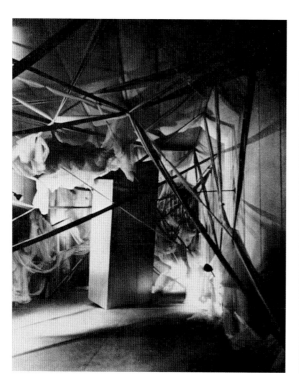

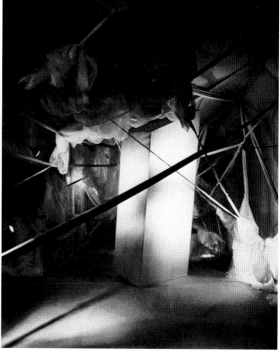

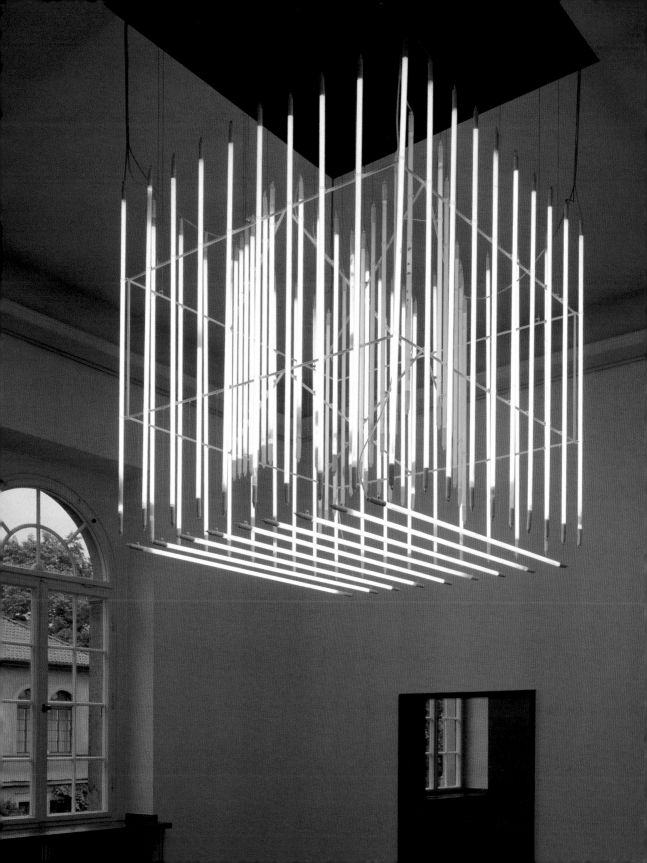

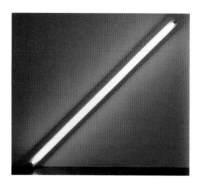

Dan Flavin
The Diagonal of May 25, 1963
Fluorescent tubes, 244 cm
Private collection

Neon, 1966
Two-part work, consisting of two each
fluorescent tubes 120 cm in length
Whereabouts unknown

Carlo Scarpa to create *Ambiente spaziale bianco* (White Spatial Ambience, p. 80). His design drawing and the documentary photographs by Ugo Mulas show a white room with an oval ground plan and oval-shaped entrance and exit, interspersed with several partitions with short lateral walls. Each of these shrine-like structures contained a white *Concetto spaziale*, a canvas with a single long vertical incision. The *Ambiente spaziale bianco* was a walk-in work of art, which earned Fontana the Biennale's "Gran Premio Internazionale per la Pittura" (International Grand Prize for Painting).

Fontana's last *Spatial Ambience* was created for "Documenta 4," held in 1968 in Kassel. It represented a further development, and a focusing, of the Venice design. At the end of a winding, labyrinthine course, the viewer came up against a wall with a single long vertical incision—a *Taglio* in a sheet of plaster (pp. 82–83). The color white dominating the entire installation evoked the infinity of space and a dematerialized weightlessness. At the same time, Fontana's Kassel *Ambience* seemed to fulfill the demand of the Futurist Umberto Boccioni, advanced decades before, that the viewer be "put in the middle of the picture."

"Space is the emblem of the void," Fontana said of his late installations of 1967, "the demise of the gallery as a space in which pictures are hung on the wall and sculptures small or large are displayed for sale, and art has become part of a general, social factor, so it should be more of an idea than an art work up for sale—and then you ask yourself, How can I represent all of this?" Fontana's question, for which his Kassel *Ambiente* suggested an answer, says much about the general situation of art around 1967, when the work of art as a commodity was the subject of multifarious and frequently controversial discussion. At the same time, Fontana's *Ambiente spaziale bianco,* an "emblem of the void," calls to mind another legendary show: Yves Klein's "Le Vide" (The Void) at the Galerie Iris Clert, Paris, 1958. Back in 1957 in Milan, the French artist had caused a sensation with a show of several monochrome blue paintings at the Apollinaire Gallery. Although identical in format, the paintings' prices differed—due to their differing content of "painterly sensibility," said Klein. Fontana was among the positively impressed visitors to this controversial show.

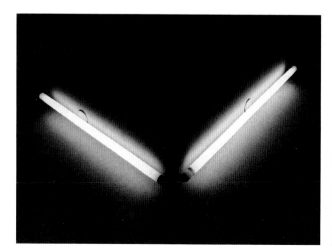

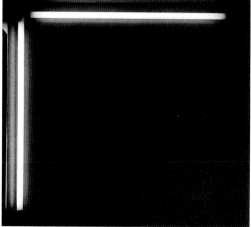

Fonti di energia (Sources of Energy), 1961
Neon ceiling for the exhibition "Italia 61"
in Turin
Seven levels of fluorescent tubes
destroyed

A year later—elaborately and with an eye to the greatest possible public impact—Klein staged another work under the title "The Void." The exhibition consisted of the whitewashed gallery space, an empty showcase, and white curtains, and was accompanied by a supporting program that was tantamount to an affair of state. The immaterial, physically non-existent "subject" of the exhibition was, again, Klein's "painterly sensibility." With "The Void," Klein drew the public's attention to a radical and provocative exhibition practice that represented a challenge for other artists as well, as indicated by Fontana's *Ambienti bianchi*.

The increasing internationalization and flow of information within the art system in the 1960s, augmented by art journals and large-scale exhibitions, resulted in increasing competition among artists. Fontana's attitude to these developments, especially as regards contemporary American art, was openly polemical. After the "Triumph of American Painting"—the phrase is by the American critic Irving Sandler—it often seemed that Americans thought "Europe was finished," as Fontana deplored. Especially the award of the Grand Prize for Painting to the American Robert Rauschenberg at the 1964 Venice Biennale seemed, to many observers, to corroborate the superiority of American art. While the 1940s and '50s had been dominated by Pablo Picasso, to whom Fontana, like many other artists of his generation, made frequent reference in works and texts, the leading figures in the 1960s were

"My art was never critical of the times, but abreast of the times."
LUCIO FONTANA, 1949

79

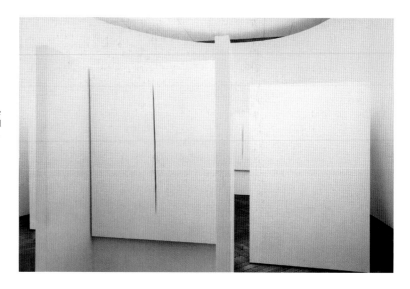

Fontana's contribution to the 1966 Venice Biennale was an installation of 20 monochrome white canvases of equal size, each with a vertical incision. In an interview, he explained self-confidently, "I cannot simply make a selection of *beautiful paintings.* Every time I have exhibited at the Biennale, by the way, I have pursued the same end—doing without prizes in favor of expressing new ideas."

above all Jackson Pollock and other Americans. As against their art, Fontana repeatedly underscored the originality of his *Buchi, Tagli,* and *Ambienti,* and the significance of innovative European artists such as Yves Klein and Piero Manzoni. Fontana accused Pollock, for instance, of being able to produce nothing but "Post-Impressionism, because he threw paint *onto* the canvas, although he wanted to *go beyond* the canvas." In his last interview, given in July 1968, Fontana told the critic Tommaso Trini that an American had asked him about the "space" in his art—evidently with an eye to current tendencies like Earth Works or Land Art, in which the actual environment became the object of artistic incursions. "'But how can you understand space?'" inquired the American. "'We've got Arizona. There's space for you …' So I said to him, 'Look, if it comes to that, I come from South America and we have the Pampas, which is twice the size of Arizona. I am not interested in the kind of space you are talking about. Mine is a different dimension'"—a spiritual dimension, one should add.

Around the middle of the 1960s, Fontana devoted a visual commentary to his *Ambienti spaziali,* a series of over 170 works collectively titled *Teatrini* (Little Theaters, pp. 74, 84–89, 91). Each of these *Little Theaters,* as art historian Jole de Sanna noted, resembles a "miniature *Ambiente.*" With their staggered planes in a shallow space, these pieces hark back to Fontana's early-1950s designs for reliefs on the fifth door of Milan Cathedral (p. 93). The *Teatrini* consisted of perforated canvases framed with a boxlike construction of lacquered plywood. The result was a stage-like, usually square or rectangular configuration that had actual spatial depth. Fontana himself spoke in this connection of "realistic Spatialism." The cut-out silhouettes of the frames cast shadows on the background, further increasing the effect of depth. The frames, of which there are many variants, are more or less "objective" in character, often bearing motifs that recall waves (p. 91) or landscapes with trees (pp. 85–86). Occasionally they appear to quote the prehistorical monumental blocks of Stonehenge (p. 88), or link up with Fontana's *Nature* series of sculptures (pp. 84, 87). In one of his *Little Theaters,* Fontana alluded to

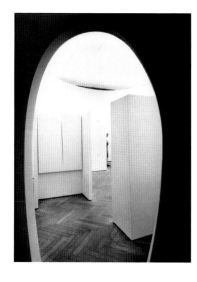

the very first "space walk." On 18 March 1965, the Soviet cosmonaut Alexei Leonov became the first man ever to step outside a space ship during flight, remaining connected to the ship by an umbilical cord. In Fontana's *Teatrino*, the perforated background evokes a starry sky, against which appears the black silhouette of a hovering figure in a space suit, connected with the frame by a curving band (p. 89).

With the playfully narrative character of his *Little Theaters*, shown for the first time in October 1965 at the Apollinaire Gallery, Milan, Fontana struck up a dialogue with Pop Art. Speaking with Carla Lonzi in 1967, he emphasized this link and defended the decorative treatment of the lacquered wood, which permitted a range of color relationships between background and frame. "I could just as well have used raw wood," Fontana said, "and people would understand it in the same way … but, as I said, life has a material side, too; there is the collector, and you have to train him, as it were, through a little deception. … Because if I used raw wood, they would immediately say, 'What a material!' This way, in contrast, somebody might feel attracted by the beauty of the material, by the form … that too contributes to their training." In 1966, when Fontana finished his *Teatrini* series, he also designed costumes and a stage set in abstract, biomorphic forms for a performance of Goffredo Petrassi's ballet *Ritratto di Don Chisciotte* (Portrait of Don Quixote, p. 81) at the Milan Scala. This project, a continuation of Fontana's concern with space in the *Ambienti spaziali*, included the viewers as actors, and combined this with his interest in the stage-like space of the *Teatrini*.

A photograph taken by Ugo Mulas in the mid-1960s shows Fontana with an ensemble of his late works—the *Fine di Dio*, *Metalli*, egg-shaped ceramics, and a horizontal format *Concetto Spaziale, Attese* (p. 90 bottom). The picture was taken in a windowless vaulted room in the basement of Fontana's Milan studio. With the pipes and wires running across the ceiling, the scene brings a submarine or space-ship to mind, a time capsule in which the artist is undertaking a journey with a selection of his works. "Art is going to be a completely

"Lucio Fontana solved the problem of space in the way Alexander the Great untied the Gordian Knot: with brute force, matter-of-factly, with a knife."
WIELAND SCHMIED, 1968

Ritratto di Don Chisciotte
(Portrait of Don Quixote), Teatro alla Scala, Milan, 1967
Sets and costumes by Lucio Fontana

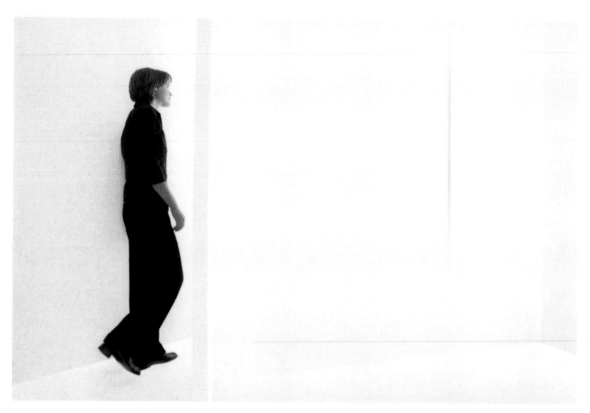

ILLUSTRATIONS PAGES 82–83:
Ambiente spaziale bianco (White Spatial
Ambience), 1968
Wood and plaster panel, 330 x 525 x 440 cm
(plaster panel 246 x 51 cm)
Reconstruction

In Fontana's installation, made in 1968 for
"Documenta 4" in Kassel, a labyrinthine, bright-
ly illuminated construction led to a vertically
incised plaster wall. The artist explained his
limitation to the color white as an expression
of infinity and a liberation from matter. A year
previously he had stated in an undated letter to
Giò Ponti that matter or material was "merely
an excuse for capturing light."

Concetto spaziale, Teatrino, 1965
Watercolor on canvas and lacquered wooden frame, 178 x 192 cm
Rome, Galleria Nazionale d'Arte Moderna

Concetto spaziale, Teatrino, 1965
Watercolor on canvas and lacquered wooden frame,
175 x 178 cm
Whereabouts unknown

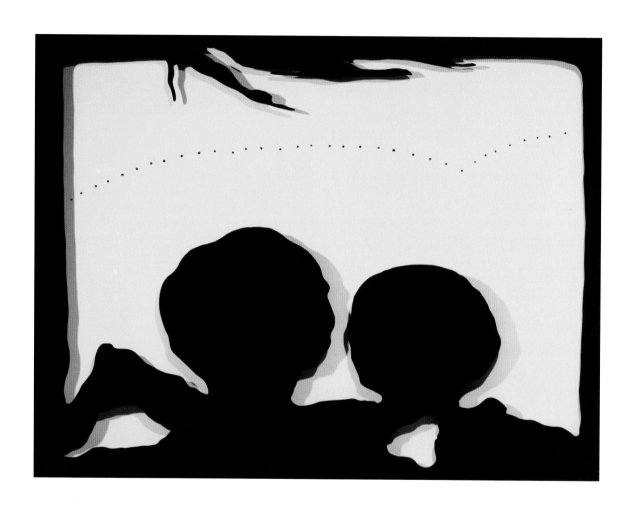

Concetto spaziale, Teatrino, 1965
Watercolor on canvas and lacquered wooden frame, 128.5 x 166.5 cm
Brussels, Musées Royaux des Beaux-Arts de Belgique

Concetto spaziale, Teatrino, 1966
Watercolor on canvas and lacquered wooden frame, 120 x 120 cm
Hamburg, private collection

Concetto spaziale, Teatrino, 1966
Watercolor on canvas and lacquered
wooden frame, 110 x 110 cm
Madrid, private collection

different thing," he prophesied in one of his last interviews in 1968. "Not an object, nor a form … Nothing more to do with bourgeois consumption, beauty attached to a sellable object. Art is going to become infinite, immensity, immaterial, philosophy. Enough of the bourgeois function of art. Open the doors." With this statement Fontana did justice to the spirit of the late 1960s, an historical moment characterized by international campus and other protest movements against the Vietnam War, against racial discrimination and social injustice, when Western capitalism came under radical fire from many quarters. Art discussions revolved around "the dematerialization of the art object" in Conceptual Art, a democratization of art "consumption" in the form of reasonably-priced editions and multiples, and the dissemination of art through mass media such as books and periodicals, radio and television. Yet Fontana's prediction of the end of the "bourgeois function of art" would never be fulfilled—a disappointment he was spared. He died in September 1968 in Varese.

During the final years of his life, institutions in the United States and several European countries devoted retrospectives to Fontana, and numbers of shows were held in Italian and international galleries. "The artist has to cope with a pressing market demand," Jole de Sanna described the first months of the year 1968. At that period, contemporary art was being increasingly discovered as an investment. In autumn 1970, the German business magazine *Capital* published its first "Kunstkompass," or Art Compass, a controversial barometer of contemporary artists' reputations. Based on their presence in exhibitions and publications, artists were ranked according to their degree of international recognition. In 1970, Fontana made the top three, right behind Robert Rauschenberg and Victor Vasarely.

As a role model, supporter and collector of a younger generation, Fontana was already the subject of many homages during his lifetime. The July 1961 issue of the journal of the German artists group Zero, *Zero 3*, contained an early "Homage to Fontana." When he was not invited to participate in "Documenta 3" in 1964, the Zero artists Heinz Mack, Otto Piene, and Günther Uecker devoted an installation in light to him, *Hommage à Lucio Fontana.* A year after his death, the Kunst- und Museumsverein Wuppertal mounted a retrospective under the same title. It contained 41 Fontana works, almost exclusively from German collections, alongside pieces by other artists, such as Agostino Bonalumi, Enrico Castellani, Yves Klein, Piero Manzoni, Francesco lo Savio, Heinz Mack, Otto Piene, and Günther Uecker. "We know," wrote Günter Aust of Fontana in the catalogue, "that he preferred to see his paintings and sculptures exhibited among works of the younger generation rather than beside those of his contemporaries." This preference was reflected in Fontana's own collection, which included Yves Klein, Arman and Jean Tinguely, Rafael Soto, Alberto Burri, Luciano Fabro and Pino Pascali; from 1958–60, he had frequently exhibited with Piero Manzoni. Fontana stood for the transcendence of the gestural, abstract painting of Art informel, and was viewed within his own generation as the most influential artist on the international scene, even surpassing illustrious contemporaries like Henry Moore, Alberto Giacometti, and Jean Dubuffet.

When the Italian critic Carla Lonzi conducted a number of exhaustive interviews with artists in 1967, in addition to Fontana she invited several younger artists associated with the emergent "Arte Povera," including Jannis Kounellis, Pino Pascali, and Giulio Paolini. As a result, Fontana came to be

"Even if the old lion is tamed, he remains, as Raffaele Carrieri recently wrote, 'the scandal and honor of three generations.'"
LEONARDO SINISGALLI, 1967

Concetto spaziale, Teatrino, 1965
Watercolor on canvas and lacquered wooden frame, 175 x 175 cm
Milan, Fondazione Lucio Fontana

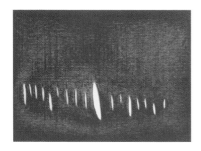

Rosemarie Trockel
Untitled, 1993
Silkscreen on Plexiglas, 98 x 135 cm
One-off work
Munich, Goetz Collection

ILLUSTRATION BELOW:
Fontana in the basement of his studio,
Corso Monforte, Milan, c. 1962

viewed as a predecessor of later tendencies, not only "Arte Povera" but even Conceptual Art.

On the occasion of a 1977 retrospective at the Guggenheim Museum, New York, curator Thomas M. Messer described Fontana as "proto-conceptual," and the Argentine conceptual artist David Lamelas spoke of the great influence Fontana had had on him. Now, the notion of a "predecessor" may be a methodologically dubious construct, a rhetorical artifact, as the curator of a large Fontana retrospective, Bernard Blistène, has pointed out. Yet as the continual presence of Fontana's art not only in today's museums and galleries, but indirectly in the work of other artists (p. 90 top) suggests, Fontana's art, as he himself wrote to the critic and publisher Giampiero Giani back in 1949, is still perceived as "abreast of the times."

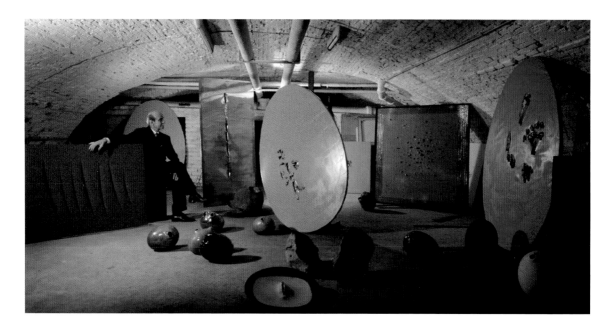

Concetto spaziale, Teatrino, 1965
Watercolor on canvas and lacquered wooden frame, 152 x 152 cm
Milan, private collection

Lucio Fontana 1899–1968
Chronology

Lucio Fontana, 1929–1930

1899 Lucio Fontana was born on 19 February in Rosario de Santa Fe, Argentina. His father, Luigi Fontana, who had emigrated to Argentina in 1891, came of a family of sculptors and stonemasons in Varese, Italy, who worked for private and public clients. His mother, Lucia Bottini, was an Argentine actress of Italian descent.

1905 Luigi Fontana separated from Lucia Bottini and married Anita Campiglio. Lucio was sent to Italy to attend school, staying with relatives in Varese.

1914–1915 Luigi Fontana returned to Italy with his wife and her three sons, settling in Milan. Lucio attended the School of Building Trades at Carlo Cattaneo Technical Institute.

1917–1918 Served as a volunteer in World War I, was wounded and sent on leave. Resumed his studies and graduated with an engineering degree.

1920 Enrolled in the Accademia di Belle Arte di Brera in Milan.

1922 Returned with his family to Argentina. Working in his father's studio, Fontana produced his first sculptures, in a traditional academic style.

1924 Opened his own sculpture studio in Rosario de Santa Fe; won a competition for a memorial plaque for Louis Pasteur.

1925 First participation in an exhibition, "VIII Salón de Bellas Artes," in Rosario de Santa Fe. Death of his mother.

1926 First ceramic sculpture. Participated in the "1. Salón de Artistas Rosarinos," where his work won an award. Received a further award for a tomb design, which he would execute the following year.

1927 Returned to Milan and re-enrolled in the Brera Academy. Studied until 1930 with the sculptor Adolfo Wildt, a representative of Symbolism. Began exhibiting on a regular basis.

1929 Designed tombs for the Cimiterio Monumentale in Milan. Was introduced by the sculptor Fausto Melotti to a group of architects who worked in a style known as Rationalism. One of these was Edoardo Persico, owner of the Galleria del Milione, which specialized in abstract art.

1930 Graduated from the Brera Academy. Participated in the XVII Venice Biennale (*Eve* and *Vittoria fascista*, p. 20 bottom) and in the group exhibition "Studi di artisti lombardi noti e giovanissimi" at Galleria del Milione (*Uomo nero*, p. 17). Met Teresita Rasini, his wife-to-be. Abstract design for a fountain, a memorial to the Lombardic sculptor Giuseppe Grandi.

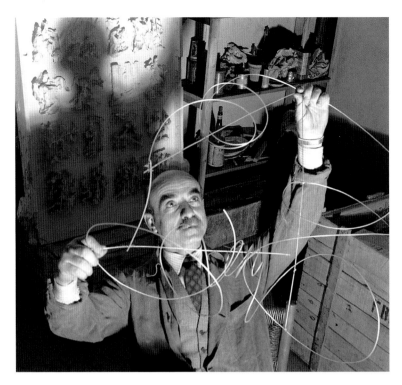

Lucio Fontana at work, 1951

younger artists connected with the academy led to the publication of the *Manifiesto Blanco* (White Manifesto). Death of Fontana's father.

1931 First one-man show at Galleria del Milione.

1933 Participation in the V Milan Triennale. Won a competition in Milan for a bust of Mussolini. First polychrome ceramics.

1935 Joined the artists group "Abstraction-Création," which had been established in Paris in 1931. In Turin, participated in the "Prima mostra collettiva di arte astratta italiana" (First Group Exhibition of Italian Abstract Art).

1936 Active in the ceramics workshop of Giuseppe Mazzotti in Albisola Mare. Publication of first monograph on Fontana, by Edoardo Persico.

1937 In collaboration with Luciano Baldessari and Renzo Zavanella, designed a triumphal arch commemorating Italy's conquest of

Ethiopia. Participated in the Paris World Fair. Active in the Sèvres ceramics workshops.

1938 Filippo Tommaso Marinetti mentioned Fontana as an "abstract ceramicist" in the Futurist manifesto *Ceramica e Aeroceramica* (Ceramics and Aeroceramics).

1939 Joined the group "Corrente," which had been established the previous year. Participated in the "III Quadriennale d'Arte Nazionale" in Rome.

1940 Returned to Argentina, where he would live primarily in Buenos Aires until 1947. Began working in a figurative style in the hope of finding a market for his art.

1946 With Jorge Romero Brest, Jorge Larco, and Emilio Pettoruti, founded the Academia de Altamira in Buenos Aires. Discussions with

1947 Returned in April to Milan, where he founded the movement "Spazialismo." From that point on, Fontana would entitle all of his works *Concetto spaziale* (Spatial Concept), giving a different subtitle to each group of related works. In May, together with Giorgio Kaisserlian, Beniamino Joppolo, and Milena Milani, signed the *Primo Manifesto dello Spazialismo* (First Manifesto of Spatialism).

1948 Signed the *Secondo Manifesto dello Spazialismo* (Second Manifesto of Spatialism) together with Gianni Dova, Joppolo, Kaisserlian, Milani, and Antonio Tullier.

1949 Emergence of first *Buchi* (Perforations), sheets of perforated paper mounted on canvas and worked both from the front and back. Exhibited first spatial installation, *Ambiente spaziale a luce nera* (p. 27), at the Galleria del Naviglio, Milan.

Lucio Fontana and his wife Teresita in the courtyard of his Milan studio, 1956

Anton Giulio Ambrosini published the manifesto *Lo spazialismo e la pittura italiana nel secolo XX* (Spatialism and Italian Painting in the Twentieth Century).

1954 Participated in the XXVII Venice Biennale with a one-man show. Began the series of *Gessi* (Pastels, pp. 36–37) and *Barocchi* (oil paintings with glass and asphalt, pp. 34–35).

1956 Inception of the series *Inchiostri* (Inks, pp. 38–39). Collaborated on several architectural projects.

1957 Fontana commenced the *Carte* (Papers, pp. 40–41) and *Olii* (Oil Paintings, pp. 63–65, 68) series.

1958 Signed his *Buchi* with his thumbprint. In the context of the *Inchiostri* series, began the *Tagli* (Incisions, pp. 46–53) in late 1958. Co-signatory of the *VII Manifesto tecnico dello Spazialismo*.

1959 First exhibition of the 2, at the ICA London. Participation in "Documenta 2," Kassel. Fontana began the *Quanta*, a group of works comprising multiple canvases with

1950 Co-signatory to the third manifesto of Spatialism, *Proposta di un regolamento* (Proposal for a Set of Rules). Designs and maquettes for the fifth door of Milan Cathedral (pp. 69 top, 93).

1951 Began a series of *Pietre* (Stones, p. 33). Authored the *Manifesto tecnico dello Spazialismo* (Technical Manifesto of Spatialism). Executed a neon arabesque for the IX Milan Triennale. With other artists, signed the fourth *Manifesto dell'arte spaziale* (Manifesto of Spatialist Art).

1952 Fontana and other Spatialist artists appeared in an experimental television program on the RAI national network and presented their *Manifesto del Movimento Spaziale per la Televisione* (Manifesto of the Spatialist Movement for Television). Married Teresita Rasini.

1953 For the "XXXII Fiera di Milano," Fontana designed a cinema ceiling, employing perforations and lighting effects, and created a curving band of industrial steel for the facade of the Sidercomit Pavilion.

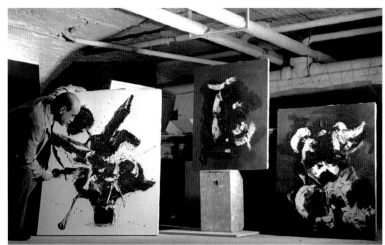

incisions or perforations designed for variable presentation, and spherical ceramics entitled *Nature* (pp. 42–45).

1961 First solo show in the U.S., at Martha Jackson Gallery, New York. Commencement of the *Metalli* series (pp. 66–67).

1962 Design of a monument to the antifascist resistance (*Monumento alla Resistenza*) in Cuneo (not executed). One-man show in Germany, at the Städtische Museum Leverkusen (Leverkusen City Museum).

1963 Beginning of the series *Fine di Dio* (The End of God, pp. 72–73), monochrome oval paintings with perforations or incisions.

1964 Fontana began to inscribe short texts on the back of his canvases. Produced a group of works entitled *Teatrini* (Little Theaters, pp. 74, 84–89, 91), perforated canvases in lacquered wood frameworks. Designed the *Ambiente spaziale, Utopie* for the XIII Milan Triennale.

1966 *Ambiente spaziale bianco* (p. 80) shown at the XXXIII Venice Biennale. Solo exhibition at the Walker Art Center, Minneapolis.

1967 Worked on the *Ellisi*, elliptical wooden pieces with a monochrome lacquer finish and mechanically produced perforations (p. 71).

Important retrospective at the Stedelijik Museum Amsterdam, which then traveled to several other cities.

1968 Exhibited an *Ambiente spaziale* at "Documenta 4," Kassel, and the XXXIV Venice Biennale. Fontana died on 7 September in Varese.

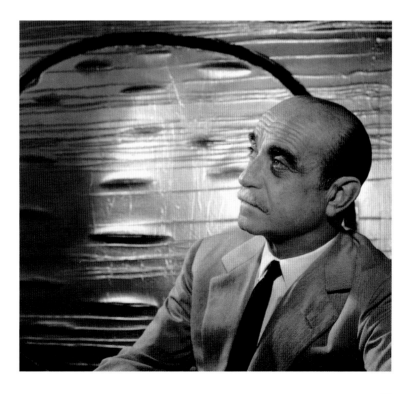

Bibliography

Amaduzzi, Isabella: *Io sono uno scultore. Lucio Fontana nella Milano degli anni Trenta.* Milan, 1999.

Bois, Yve-Alain: "Fontana scatologue," *Critique,* no. 502, March 1989, pp. 155–168.

Bois, Yve-Alain: "Fontana's Base Materialism," *Art in America,* no. 77, April 1989, pp. 238–249, 279.

Buchloh, Benjamin H. D.: "Lucio Fontana," *America—Bride of the Sun,* exh. cat., Royal Museum of Fine Arts, Antwerp, 1992, pp. 358–360.

Campiglio, Paolo (ed.): *Lucio Fontana, Lettere 1919–1968.* Milan, 1999.

Crispolti, Enrico (ed.): Lucio Fontana, *Catalogo generale,* 2 vols., Milan, 1986.

Joppolo, Giovanni: *Lucio Fontana.* Marseille, 1992.

Lista, Giovanni: "The Cosmos as Finitude: From Boccioni's Chromogony to Fontana's Spatial Art," *Cosmos,* ed. Jean Clair, exh. cat., Palazzo Grassi, Venice, 2000, pp. 93–97.

Lonzi, Carla: *Autoritratto.* Bari, 1969.

Lucio Fontana. Essays by Jan van der Marck and Enrico Crispolti, 2 vols., Brussels, 1974.

Lucio Fontana. Exh. cat., Centre Georges Pompidou, Musée National d'Art Moderne, Paris, 1987.

Messer, Thomas M.: *Lucio Fontana Retrospektive.* Exh. cat., Kunsthalle Schirn, Frankfurt am Main, 1996; Museum Moderner Kunst Stiftung Ludwig, Vienna, 1996–97.

Pelzer, Birgit: "Das Extime. Versuch über Lucio Fontana," *Lehmbruck, Brancusi, Léger, Bonnard, Klee, Fontana, Morandi.* Exh. cat., Kunstmuseum Winterthur, 1997, pp. 137–177.

Renn, Wendelin (ed.): *Der unbekannte Fontana.* Exh. cat., Städtische Galerie Villingen-Schwenningen, Ostfildern-Ruit, 2003.

De Sanna, Jole: *Lucio Fontana. Materia Spazio Concetto.* Milan, 1993.

Schulz-Hoffmann, Carla: *Lucio Fontana.* Munich, 1983.

Schulz-Hoffmann, Carla: "Das Ambiente Nero von Lucio Fontana: Prototyp des Environments, Mailand 1949," *Die Kunst der Ausstellung,* ed. Bernd Klüser and Katharina Hegewisch, Frankfurt am Main and Leipzig, 1991, pp. 110–115.

White, Anthony: "Lucio Fontana: Between Utopia and Kitsch," *Grey Room,* no. 5, 2001, pp. 54–57.

Whitfield, Sarah: *Lucio Fontana.* Exh. cat., Hayward Gallery, London, 1999–2000.

Photo Credits